the joy of

nature photography

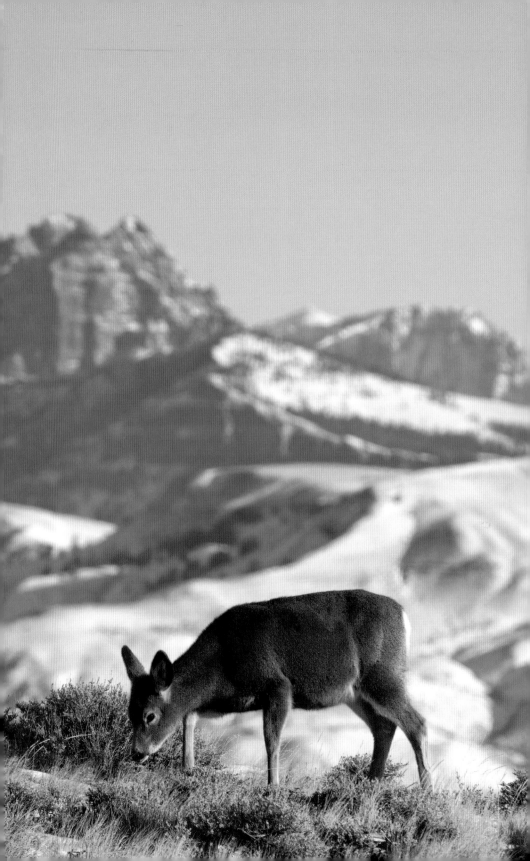

the joy of

nature photography

101 TIPS TO IMPROVE YOUR OUTDOOR PHOTOS

Steve Price

Skyhorse Publishing

Skyhorse Publishing books may be purchased in bulk at special discounts for sales promotion, corporate gifts, fund-raising, or educational purposes. Special editions can also be created to specifications. For details, contact the Special Sales Department, Skyhorse Publishing, 307 West 36th Street, 11th Floor, New York, NY 10018 or info@skyhorsepublishing.com.

Skyhorse® and Skyhorse Publishing® are registered trademarks of Skyhorse Publishing, Inc.®, a Delaware corporation.

Visit our website at www.skyhorsepublishing.com.

10 9 8 7 6 5 4 3 2 1

Library of Congress Cataloging-in-Publication Data is available on file.

ISBN: 978-1-63220-691-6
Ebook ISBN: 978-1-63220-947-4

Cover design by Owen Corrigan
Cover photos © Steve Price

Printed in China

To my
wonderful
daughter Valerie,
an extremely talented
landscape photographer and some
of whose photographs I am
proud to include in this book.

CONTENTS

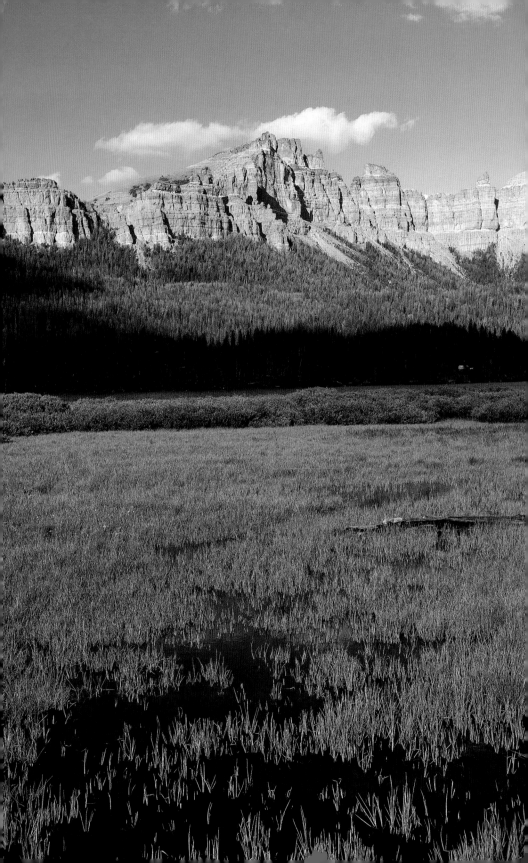

Introduction

THE SMALL puddle of water splashing from side to side in the bottom of the canoe did not seem threatening, and I paid little attention to it, even though it grew by a few drops each time David and I switched paddling sides to keep our arm muscles from getting fatigued. It was our first morning of a two-day trip down the Yadkin River in North Carolina, and for both of us, the excitement of the adventure commanded all our attention. I was fourteen years old and exploring a brand new world.

Too late, I realized the little puddle of water had been sliding further down the canoe as it grew, and had reached the small Brownie box camera I had placed under my seat for quick access. When I grabbed it in a panic, water ran off the camera in a solid stream, and when I made a quick test to check the shutter and then advance the film, the knob would barely turn because inside the roll of film was already a soggy mess.

I remember my disappointment clearly, not only because now I could not record any portion of our canoe trip but also because it was the only camera our family owned. I had been entrusted with its safekeeping, and failed, barely three hours into our trip. Letting a camera get wet was a mistake I vowed not to make again.

But I did make that mistake again, as well as plenty of others, while carving out a career as an outdoor photojournalist. Several years ago, while presenting an outdoor photography seminar for the well-known Recreational Equipment, Inc. (REI) store in Dallas, I made the comment to my class that I thought at one time I

had made "every mistake in the book" during my career, but I quickly realized that wasn't true, since I was still making mistakes as a photographer.

That was probably when the idea for this book was born, with the premise of telling readers how to avoid making many of the mistakes I had made. While it is true that the only requirement for a photograph to be successful is that the photographer who took the picture likes it, it is also true that virtually all photographers want others to also like their pictures. To that end, avoiding simple, careless mistakes becomes very important, and forms a vital part of this book.

Photography has changed a great deal during the half century since my ill-fated canoe trip, but at the same time, it has not changed at all. The key factors of composition, understanding light, and using color remain exactly the same. Learning how to consistently blend these, and other factors, into successful photographs, is also a major part of this book. I have included 101 tips, but it could easily have been more; hopefully, following some of these I have presented will give you a good starting point.

Digital photography makes learning photography easier than ever before, if you take the time to learn what it is telling you. In an instant, you can see if you captured the image you wanted by looking at the camera's LCD viewing screen. A histogram shows your exposure, and enlarging the image tells you if your focus was sharp. During my early trips to Africa and other places, it sometimes took months to get my processed film back to learn if I'd gotten it right, all the while knowing that if I hadn't done it right, there would be no second chances to try it again.

With digital equipment, you have all the second chances you want, but hopefully, you won't need them, even if there is water in the bottom of the canoe.

Steve Price
Tijeras, New Mexico

① First, a Little History

THE FATHER of wildlife and nature photography is considered to be George Shiras III (1859–1942), who, in 1906 had seventy-four of his photographs published in *National Geographic* magazine. Indeed, the article, titled "Hunting Wild Game With Flashlight and Camera" filled the entire magazine, and was so well received by readers it was reprinted two years later. Shiras was later named to the board of managers for the National Geographic Society, and in 1935 *National Geographic* published his book of the same title.

The word "flashlight" is a little misleading in today's photographic world, however. Shiras did not use the type of flashlights we commonly keep in a toolbox or beside the bed in a nightstand drawer. Rather, he used trays filled with magnesium powder that literally exploded in a loud flash. Later, Shiras began using three separate alcohol lamps and a rubber bulb that, when he squeezed it, sprayed flash powder into the burning lamps. Always experimenting for something better, Shiras also used baited trip wires the animals themselves would set off to trigger his flash units.

As primitive as these techniques sound today, with them Shiras produced some of the very first nighttime images of wildlife the world had ever seen. A lawyer by

education (Yale, 1883), Shiras also served one term in Congress as a representative from Pennsylvania. It was in 1889, after years of hunting wildlife with a rifle, that he put the weapon aside and turned instead to photography.

He was also an ardent conservationist, and while in Congress Shiras introduced what is now known as the Federal Migratory Bird Law. He also helped write the legislation that led to the creation of Olympic National Park. During one of his subsequent trips to Yellowstone National Park, he discovered a separate subspecies of moose, now known as the Shiras Moose, *Alces americanus shirasi*.

Shiras used a type of camera probably completely unknown to many of today's digital photographers, a 4x5 sheet film model. The first digital camera was not invented until 1975, more than three decades after his death. That camera, invented by Steve Sasson, a twenty-year-old engineer at Eastman Kodak, wasn't really a consumer-type camera, but it did change the world of photography forever. Sasson and his team spent a year creating the eight-pound camera, and took their first digital image, in black and white, in December 1975.

From there, the technology curve rose sharply, but it was not until 1988 that the first true digital camera designed for consumer use was introduced. It was the DS-1P by Fuji. Kodak regained the lead in the digital race in 1991 with the introduction of the Kodak DCS, the first truly commercial digital SLR camera. It featured a Nikon F3 body in which all the digital electronics were fitted into the camera's film chamber.

Three years later, Kodak, working with the Associated Press to create a digital camera more suitable to photojournalists, modified a newer Nikon N90 body to produce the Kodak/AP NC200 camera. It was still a low resolution 1.3 megapixel model, arcane by today's standards, but it did use removable memory cards, which are still standard today, and it offered enough ISO sensitivity (1600, also arcane by today's standards) for journalists to shoot suitable available light images. The camera cost $17,950, but that year the *Vancouver Sun* began using them and became the first newspaper in the world to convert exclusively to digital photography.

The handwriting, as they say, was on the wall, even though digital cameras at this time were still much too expensive for general consumers. Nikon helped change that in 1999 with its introduction of the D1, which featured 2.7 megapixel quality, but more importantly, sold for around $5,000. Suddenly, digital photography was put into the price range of serious professionals, since all their previous Nikkor lenses could be used on the D1 body. The following year, Fujifilm introduced its Finepix S1 Pro, which sold for approximately $3,500 and also used Nikkor lenses. With those two cameras, along with Canon's EOS D30, general consumers finally had a choice of digital cameras they could afford.

Even though in 2001 more than 840 million rolls of 35mm film were sold and about 90% of all US households used film cameras, the tidal change to digital cameras began in earnest, and today the number of photographers who still use film cameras is very small compared to those who use digital equipment. The growth of digital popularity has spurred manufacturers to push the technology curve faster and higher, as well, so that the advantages of using digital photography continue to increase.

Digital cameras allow you to see your photo instantly to determine if you captured the shot; there is no more nervous waiting for hours, days, or even weeks to have film processed and then studied to see the results. Just as importantly, digital images can be "processed" in a computer where they can be enhanced and corrected, in case you didn't get exactly what you wanted. As an outdoor photographer, you can literally do this correcting in the field, too.

As you'll quickly discover, today's digital equipment is far more versatile than film photography, as much of the technology curve in recent years has centered around sensor sensitivity. It is now possible to take excellent images in low-light conditions that were never possible with film, and to crop and enlarge smaller portions of an image without losing any appreciable quality.

Another advantage of shooting in digital that every photographer comes to appreciate is that it's cheaper image-per-image than film shooting. That's because you don't have to pay for your discards the way you do with 35mm transparencies. You simply hit the "trash" button on your camera and they're gone, leaving you with space to re-shoot as you wish.

And, of course, digital images can be sent worldwide to friends and businesses through your computer in seconds. If you're just traveling on vacation, you can show family and friends what you're doing practically as you're actually doing it, and if you're a pro on assignment, you can keep your editors informed of your progress on a daily basis. You don't have to haul bags of exposed film around until you complete your assignment, then struggle to get that film through airport security checkpoints without going through an X-ray machine.

Digital photography offers all these advantages, and more. There are dozens of different makes and models of digital cameras available today, so getting started is not that difficult. It has been just over a century since George Shiras excited the world with his nighttime shots of wildlife, with equipment that few can scarcely imagine today, but now with our modern digital cameras, it's actually possible for practically any photographer to duplicate the types of shots he made, and it's certainly much easier.

2

Choosing Your Equipment

TODAY THERE are dozens of digital single lens reflex (DSLR) cameras, an almost overwhelming choice of lenses, and an uncountable number of accessory items available to photographers, so the choice of what to purchase is seldom an easy one to make, especially if it's your first digital camera. The digital revolution, in full speed for more than a decade now, shows no sign of slowing, so your equipment choices may become even more difficult in the years ahead.

Your basic considerations should be to purchase a camera from a well-known manufacturer, such as Nikon, Canon, Sony, or one of the other established companies. Also, choose a camera that allows you to expand with additional interchangeable lenses and accessories. Even if you don't plan to use telephoto or extreme wide-angle lenses now, you may in the future. Prices of camera bodies vary greatly, depending on the features offered, so consider carefully what you plan to photograph and how you'll be using your new purchase.

Leading photography magazines and internet sites publish technical reviews of new cameras and lenses each month that can provide a good starting point for

you. Photography stores and local photographers themselves can also offer sound advice to help you make your choice.

Personal Interlude

When my longtime friend and frequent fishing companion Bruce Williams suggested a redfishing trip in Aransas Bay around the southern tip of Matagorda Island along the Texas Gulf Coast, I immediately accepted, but with an ulterior motive in mind. The fishing there is legendary, but so is the birding. I had purchased my first digital camera only a few months earlier and was still learning the new system, so in addition to catching redfish, I'd have a great opportunity to practice digital techniques on one of my favorite subjects, wading birds like egrets and herons.

We piled our fishing tackle, camping gear, and my cameras into Bruce's boat and motored down the bay to the very tip of the island where we pitched our tents at the edge of the sand dunes a few steps from the water. Across the dunes we could see and hear Gulf waves breaking on the beach. It was an idyllic area, and the birds were already there—a large contingent of gulls, along with white, snowy, and reddish egrets—that showed no concern at our presence.

As it turned out, the fishing the next morning was not very productive, so as Bruce continued wading and casting the shallow bay, I returned to our camp to work on my photography. The tide was falling, and about a hundred feet away across that part of the bay, several white egrets were feeding on small baitfish still remaining in the shallow water. I grabbed the new digital camera and attached a 2X teleconverter with my 300mm telephoto lens, a combination that gave me an effective focal length of 900mm.

I simply sat down on our food cooler with the tripod in front of me. The sun was bright and the light could not have been more harsh for filming, especially white subjects like egrets, but I started shooting anyway because one particular bird was putting on quite a show. Spreading its wings as if shading the water, the egret would run through the shallows, actually herding the baitfish together where it could easily grab them with its long bill.

When those baitfish scattered, the bird changed directions and ran to another spot, herding another group of fish practically up on the dry sand. I filmed nonstop for at least half an hour as the egret ran back and forth in front of me. Eventually, the bird flew to a different area, and surprisingly, even though other egrets were present, none followed suit with similar running tactics. It was not until that evening when I downloaded the images into my computer that I realized I had captured a photo of fleeing baitfish actually jumping out of the water in their panic to escape.

Some scenes, such as this egret chasing baitfish for a meal, are so compelling or unusual that you should photograph them, regardless of the light conditions. This shot was taken under bright sunlight with a 300mm telephoto lens and a 2X teleconverter.

Tip #1: How to Choose a Digital Camera

DSLRs range from entry-level models to full professional cameras, and thus are suitable for hobbyists as well as experienced photographers. They produce the highest image quality, low-light sensitivity, and most accurate exposure technology available.

These cameras are usually categorized into three separate but distinct classes: entry level, intermediate, and professional. The differences between these cameras are largely performance options and cost, with entry level models the least expensive and professional models the most advanced.

Choosing a DSLR should depend on your photographic experience and skill, the level of your desire to advance in photography, the type of images you want to take, and of course, personal cost limitations. All levels of DSLR cameras offer interchangeable lenses and a large selection of accessories.

Entry-level DSLR cameras are designed to be the first step up from the more basic compact, point-and-shoot cameras. They are very user friendly and do not offer as many image control choices. You can still adjust shutter speeds and exposure settings, but these cameras typically also offer a number of automatic shooting modes in which the camera picks the exposure for you. These choices might be "landscape," "sports," "portraits," and others; you choose which fits your type of image, and adjust the dial to that mode. The camera does the rest. If you are a newcomer to photography, or not really serious about pursuing photography further than casual shooting, an entry-level camera would likely be a good choice for you.

RIGHT: Many companies produce DSLR cameras today, designed for professional, intermediate, and entry-level photographers. All have different features, so choose one that suits the type of photography you want to do.

If you have some photographic experience, or are serious about expanding your skills, an intermediate DSLR would be a better choice. This is the largest category of DSLR cameras, and while they are slightly more expensive than entry-level models, they are more technically advanced and offer more exposure options you can control manually. Auto focus performance will be faster than on an entry-level camera, and you'll generally have a faster continuous shooting rate, too. These can often be purchased as a kit with one or sometimes two lenses, as well (thus the term "kit lenses").

Many beginning photographers with little experience jump straight into this category, skipping the entry-level stage, without any problems, and if you have thoughts of continuing further in photography, this is the category of cameras to study. Many pros use one of these models as a backup camera, too.

The professional level of DSLR cameras offer the most advanced technology available, and produce the highest quality images because of those advancements. All of the standard features found on intermediate cameras are improved at this level, along with other image control options, and the cameras are usually a little larger and heavier because of the increased electronics they include.

If you're a beginner, don't jump straight into one of these professional models. It takes some experience to fully understand and utilize all the features they offer; start with an intermediate camera, then move up to a professional model and let your intermediate become your backup. You can easily do this without changing camera brands so the lenses you have will fit both models.

Tip #2: Choosing an Image Sensor

The image sensor inside your camera collects and stores the information, in the form of pixels, of each picture you shoot. Sensors are produced in two primary sizes, a slightly smaller one known as APS-C, and a larger one known as Full Frame. You can't choose a camera body and then pick the sensor you want; rather, you may want to choose your camera body because of the size of its sensor.

The smaller APS-C sensors are the most common, and are found on the majority of intermediate-level cameras, as well as on some professional models. Virtually all entry-level cameras also have APS-C sensors.

The greatest noticeable difference between these two sensors is known as the magnification factor. The APS-C sensor results in a 1.5 or 1.6 (depending on the camera) increase in the focal length of any lens used on that camera. A standard 50mm lens becomes the equivalent of a 75mm lens, and a 300mm telephoto

RIGHT: The majority of DSLR cameras today have smaller APS-C image sensors that provide a magnification factor of 1.5 or 1.6 for every lens. A 200mm lens becomes a 300mm, which is how this tiger swallowtail butterfly was photographed.

becomes a 450mm lens. If wildlife photography is a field you want to concentrate in, choosing a camera with an APS-C sensor is certainly worth considering.

A Full Frame sensor is slightly larger and thus able to collect more information about your image. This results in greater detail and overall improved image quality, as well as improved low-light photography capabilities. You can crop your photo tighter or enlarge your final prints to a greater size without loss of quality, too. Landscape photographers like these sensors, but they're certainly suitable for wildlife, as well. The majority of professional cameras today offer Full Frame sensors, although some are available with APS-C sensors.

Tip #3: Count the Pixels

In digital cameras, light through your lens is collected on the sensor each time you shoot a picture. The collectors of this light are known as pixels, and each one usually collects only one color. They look like tiny squares; you can see this on your

ABOVE: Today's digital cameras feature different megapixel counts; the higher this number, the larger the size of the print that can be made. High megapixel counts in a camera usually indicate advanced technology overall.

computer if you keep enlarging a photograph, as eventually the entire image shows up as a collection of these little squares.

One consideration when purchasing a digital camera, although certainly not the only one, is the number of pixels on the sensor, a number described as "megapixels." One megapixel equals one million pixels, so a camera may have 12 megapixels, 15 megapixels, etc. The more megapixels a camera has, the larger the print size you can produce. In today's photography, a higher megapixel count generally indicates increased overall technology in the camera, as well.

The first digital cameras used sensors with less than 3 megapixel collecting capacity; by 2005 the standard count was around 12 megapixels, and by 2012 some cameras could boast more than 35 megapixels. In early 2015, Canon introduced a new model, the 5DS, with a 50 megapixel sensor.

As a nature and outdoor photographer, with the wide selection of DSLR cameras available, do not purchase anything with less than 12 megapixels. This will provide excellent quality images that can be enlarged to beautiful 16x20-inch and even 18x24-inch prints. If you're looking to have your photographs published, a 12 megapixel camera will definitely produce images suitable for magazines and books.

Not only will a higher megapixel count produce excellent images, it will also allow you greater cropping freedom in producing your final picture. If you don't have quite the telephoto magnification to make a distant bald eagle or whitetail deer fill your viewfinder, you can often do it on your computer when you have 12, 15, or more megapixels with which to work.

Tip #4: How to Pick a Memory Card

Today's digital cameras use memory cards to capture the images you take, just like film did in older cameras. These cards are produced in different formats (such as SD, SDHC, and CF) for various types of cameras, but all do the same thing. The three most important things you need to know about memory cards are which type your camera uses, the card's capacity, and its speed.

Most cameras today are sold without memory cards, which is why you need to know which type you have to purchase. The designation SD, which stands for secure digital, is very common and is compatible with many digital cameras. They are smaller than a postage stamp and the upper right hand corner is cut away.

SD memory cards are also designated SDHC (secure digital high capacity) and SDXC (secure digital extra capacity). Both are identical to the original SD cards, but they have higher capacities to record more images. If you own an older digital camera, make certain it will read these newer SD cards before you purchase one.

BELOW: Storage capacity in memory cards varies, depending on the size of the files you shoot and the format you use. Pick cards with both fast writing and reading speed for quicker recording and downloading.

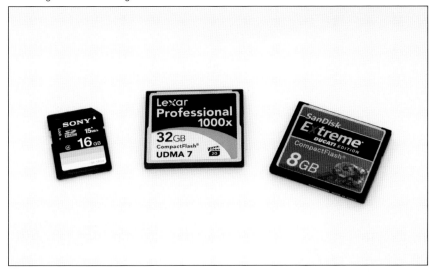

Professional digital SLR cameras generally use CF (compact flash) memory cards, which are slightly larger than SD cards. These cards have high storage capacities and very fast processing times.

Memory card storage capacity is expressed in gigabytes (GB) and terabytes (TB). The actual number of images you can record on any card will vary, due to the resolution you're using (more images for JPEG, less for RAW), and the size of your image files. If you're a serious outdoor nature and wildlife cameraman, you will eventually start using the larger RAW format, so consider using 16, 32, and even 64 GB cards.

A memory card has two designations for speed: writing speed and reading speed. As an outdoor nature photographer you want both to be fast. Writing speed is the rate at which your photos can be saved on the memory card as you're shooting, and is expressed in megabytes per second (MB/S). Get a card that has a reading speed of at least 90 megabytes a second and if you can afford it, get one that has a writing speed of 150 (or faster) MB/S.

The reading speed of a memory card describes how fast your images can be transferred from your card to your computer. If you regularly shoot larger RAW files, or perhaps a large number of JPEG files, then you definitely want a memory card with a fast reading speed so you won't be tied to your computer for an hour or longer. Again, the numbers are similar; get at least a reading speed of 95 megabytes a second and 160 MB/S or faster if you can afford it.

Major memory card manufacturers today include Delkin, Lexar, SanDisk, and Sony, and each offers memory cards with different capacities and speeds; larger capacity and faster cards are always more expensive, but always worth it.

Tip #5: Getting Wide

When choosing lenses for outdoor and nature photography, make certain you include a wide-angle lens. As its name implies, these types of lenses offer a wider angle of view than our normal vision, which is approximately the equivalent of a 50mm lens. Typically, wide-angle lenses range from 17mm to about 35mm, but even wider angle lenses are available.

The advantages of a wide-angle lens are that it allows you to shoot images of grand vistas and landscapes, such as meadows of wildflowers, mountains and mountain ranges, or waterfalls, and include a lot of foreground and background in the shot. With these lenses, you can get extremely close to your subject and keep the background in focus at the same time. They're also the lens of choice if you have to shoot in a confined space.

Don't overlook wide-angle zoom lenses as a possible purchase, since they allow you to change compositions while still maintaining the wide-angle perspective.

The best ones will offer a zoom range of perhaps 12-24mm, 17-35mm, or even 24-70mm, which extends into the short telephoto range.

With wide-angle lenses it is important to purchase a lens that matches your camera's sensor size (See Tip #2). Using a wide-angle lens designed for a camera with a smaller APS-C sensor on a camera that has a Full Frame sensor will create a problem known as vignetting, in which all four corners of your image are darkened. This will be visible through your viewfinder, and it will force you to zoom in closer to eliminate it, changing your composition in the process. Experienced camera dealers can advise you on which wide-angle lens to purchase when you tell them which type of sensor your camera has.

Tip #6: Your Workhorse Lens: 70—200mm Zoom

If you look in the camera bag of many professional outdoor nature photographers, you'll often see a 70–200mm (or 80–200mm) zoom lens, a short telephoto lens they admit is one of their most important lenses. Because of its focal length range, it can become a true workhorse for you, too.

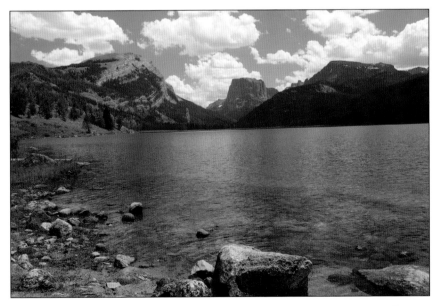

ABOVE: Using a wide-angle lens, such as this photo of Green River Lake in Wyoming, allows you to capture a broader angle of view than your normal vision, and can result in dramatic scenic and landscape images.

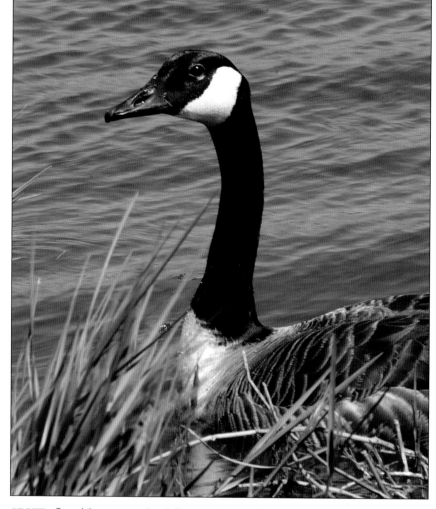

ABOVE: One of the most popular of all camera lenses is the 70-200mm, or 80-200mm telephoto, which is often described as a workhorse lens. It can be used in many different situations.

At 70mm (or 80mm, both are available), this focal length is short enough for portrait-type images and even some landscape work, while at 200mm it is long enough for moderate magnification of certain animals and birds that allow you to approach fairly close. This is an excellent lens for isolating more attractive portions of larger scenes, such as an individual peak in a line of mountains, while at the same time allowing you numerous composition choices throughout its focal length range. These lenses are easily handheld, and small enough for convenient carrying, either over your shoulder or in a camera bag or backpack. If you're filming out of an automobile, you won't need a window cushion support like you will with a longer, heavier telephoto.

This lens is generally fast enough to shoot in low-light conditions, too, especially the f/2.8 lenses, which you should seriously consider for your purchase

even though they're more expensive. A slower zoom lens of this magnification will be lighter and less expensive, but probably not as sharp. Better zooms in this class also have built-in vibration reduction systems, too. All of this will cost in the neighborhood of $2,000.

In recent years, major camera and lens manufacturers have improved these zoom lenses to the point that the best ones are as sharp as fixed focal length lenses, making this a lens you may decide to leave on your camera all the time. The zoom range of 70 or 80mm is about a 1 1/2 power magnification of what you see normally (the equivalent of about 50mm), and extends to magnify approximately four times your regular range of vision.

Tip #7: The Lure of Big Glass

The dream of most wildlife and nature photographers is to own a long telephoto lens in the 400, 500, and even 600mm class; afterall, lenses like these magnify your subject many times greater than shorter lenses and produce much more detailed images. To get a general magnification factor, divide the focal length by 50mm, which represents normal eyesight. A 500mm lens, for instance, magnifies a subject 10 times greater than how we see it.

While these types of lenses, often described as "big glass," offer distinct advantages of magnification, plus the fact this magnification allows you to stay a safe distance away from your subject, they also come with a fairly significant list of disadvantages. Big glass is extremely expensive, usually heavy and requiring tripod support, and also fairly delicate so the lenses must be handled carefully.

There are essentially two types of big glass telephotos, those known as "fast" lenses, and those known as "slow" lenses. Fast lenses have a large maximum aperture, such as f/2.8 or f/4. Physically, these are the largest lenses, since those apertures increase the size of the glass used. A lens of this type will often weigh in excess of 10 pounds. They're superb in low-light conditions, and allow faster shutter speeds, but they are also the most expensive, often costing more than $6,000.

Slower lenses, those with apertures in the range of f/5.6 or even f/8, are physically smaller because not as much glass is required, and they cost thousands of dollars less. Because today's digital cameras have more sensitive image capture sensors, it is possible to increase your ISO rating, such as from 200 to perhaps 800, and regain at least some of your higher shutter speed options.

Consider one of these slower lenses for your first big glass, then move up to a faster lens as your finances permit. Numerous used telephotos, including the fast

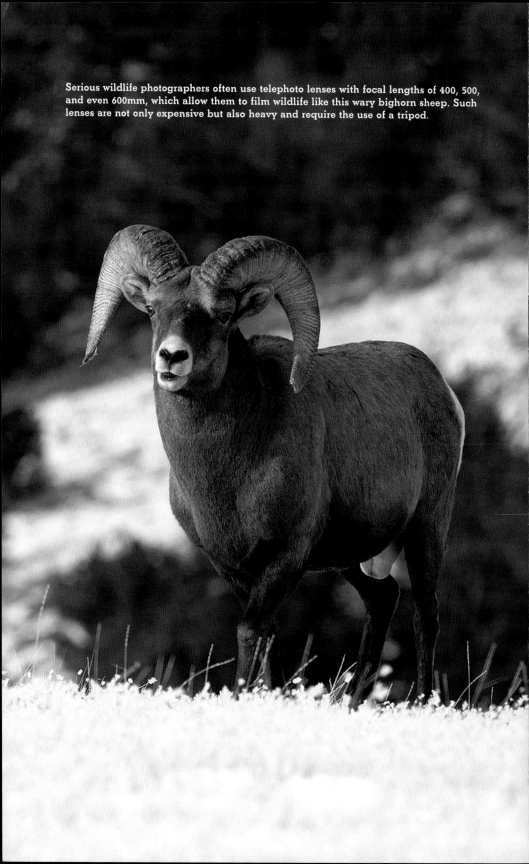

Serious wildlife photographers often use telephoto lenses with focal lengths of 400, 500, and even 600mm, which allow them to film wildlife like this wary bighorn sheep. Such lenses are not only expensive but also heavy and require the use of a tripod.

lenses, are also available at leading photographic outlet stores, not only in excellent condition but also at greatly reduced prices. Stay with well-known brands when you do purchase, to insure the best optics.

Tip #8: Enhancing Your Photos with a Polarizing Filter

Of the many filter choices available to outdoor photographers to improve image quality, polarizing filters are among the most valuable. These filters reduce glare, especially on water and snow scenes, and at the same time saturate colors in the sky, in the leaves of trees and plants, and even in clothing. This is the filter that turns the sky a darker blue, and brings the white out in clouds.

Polarizing filters are available in two styles, circular and linear. Although both look similar, circular polarizing filters are designed for cameras with autofocus, standard in the majority of today's DSLR cameras, and should be your

BELOW: To capture this reflection of the Grand Tetons on the water, a polarizing filter was used. These filters not only reduce glare but also darken the sky and help saturate colors.

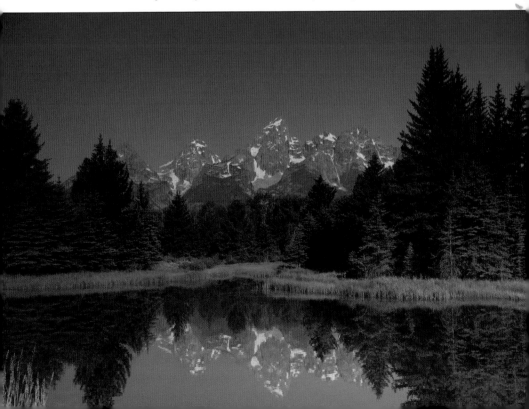

choice. Linear filters, by contrast, are designed for manual focus lenses and do not always work well when autofocus is used.

Polarizing filters are made with two separate but attached rings; one ring is threaded and screws into the front of your lens, the other ring rotates so you can dial in the amount of polarization you want in your photo. Looking through your camera viewfinder as you turn this outer ring, you can see glare disappear or the sky turn darker.

Polarizers work best when you turn your camera 90 degrees away from the sun; they will not darken the sky when the sun is directly behind you, or in front of you. They are not particularly effective on cloudy, overcast days, either.

If there is a drawback to using a polarizer, it is that putting one on your lens will take away as much as two f/stops of exposure. If this is a problem with the scene you're shooting, consider increasing your ISO or using a tripod, or both. The difference in the cost of polarizing filters is largely in their sizes for different lenses, as well as the quality of glass used.

Tip #9: Take Away Light with a Neutral Density Filter

Neutral density (ND) filters are less widely known than polarizing filters, but they're still extremely important in outdoor photography. Their purpose is to reduce the amount of light before it passes through your lens; even more importantly, graduated neutral density filters can be positioned to reduce light in only a portion of your scene.

For example, when you encounter a scene with several f/stops of dark and light exposure differences, such as a snow-capped mountain with a darker valley or treeline below, a graduated neutral density filter can be used to take away light

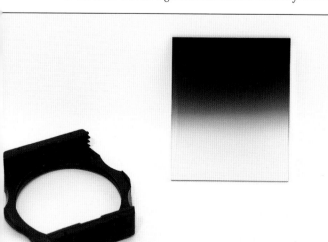

LEFT: Graduated neutral density filters help even an exposure by reducing light in part of it. Even the best digital cameras cannot always compensate for the differences in bright and shadow portions of a scene.

from only the brighter mountain part of your picture while still exposing normally for the darker valley. Thus, it reduces the exposure differences so your camera can provide a better overall exposure.

It can do this because a graduated ND filter, which is most often a three or four inch square piece of gelatin, is tinted gray across half of the filter, but transitions to clear across the remaining half. Graduated means this transition from gray to clear is not abrupt and sharp, but rather, gradual.

Filter holders that screw into your lenses are available for these types of filters, but because you don't use an ND filter all the time, you can simply hold it in front of your lens, matching the transition portion of the filter along the lighter/darker line of the scene you're photographing. No additional camera exposure changes are needed.

Neutral density filters are available in different strengths, usually described as strengths of 1, 2, or 3, with 3 being the strongest. Choosing a strength of 2 is a good start until you become accustomed to using an ND filter, and some kits are available that offer all three.

Tip #10: Choosing a Tripod

The purpose of a tripod is to help you achieve sharp photos in low-light conditions, when you're shooting longer exposures, and when you're using long lenses by providing a firm, stable support for your camera. The parts of a tripod include the leg assembly as well as a rotating head, usually purchased separately, to which you attach your camera. Tripods should become an integral part of your equipment, even though better-made carbon fiber models, which are both light and strong, are quite expensive.

The three separate legs telescope into each other in either three or four sections, so the unit may be as short as 24 or 25 inches and extend to about 48 inches high. Tripods also have a center post that can increase the working height an additional 12 to 18 inches, if needed. The center post should only be used when absolutely necessary, however, as overall stability decreases as it is extended.

The most popular type of tripod head used by nature photographers is known as a ball head, in which your camera is mounted on a ball socket. When loosened, the ball moves in any direction you point your camera, and when tightened by a single knob quickly locks into that position. Some ball heads have two adjustment knobs, one large and easy to grasp, the other much smaller. With these, you can tighten the smaller knob until it slows the ball's movement in the

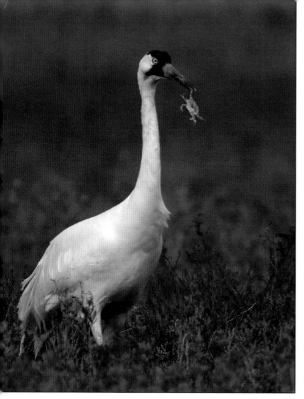

LEFT: This endangered whooping crane eating a sand crab was photographed with a 300mm telephoto lens mounted on a tripod for stability. Tripods should become a basic part of your photographic arsenal.

socket but still allows for camera movement. You can then tighten the ball easily and more quickly with the larger knob when you have your camera positioned where you want it.

Both tripods and ball heads are available in various sizes. Choose yours by the weight of your camera and lens. Purchase a tripod and head that will support more than you think you will need so if you upgrade to longer, heavier lenses, the tripod will still support them.

A different tripod head, known as the gimbal head, is often preferred by wildlife photographers because it easily balances larger lenses and still allows smooth side-to-side panning for moving subjects, especially flying birds.

Tip #11: Increasing Magnification with a Teleconverter

Teleconverters are small optical attachments that increase the magnification of your lens. They contain optical ground glass, and fit between your camera body and your lens. Typically, they are available in magnification strengths of 1.4X (40%)

and 2.0X (100%), and are best used on single focal length lenses rather than zoom lenses.

Teleconverters also cause a loss in light at any aperture; a 1.4X teleconverter will cost you one f/stop, and a 2.0X teleconverter will lose two f/stops. Thus, a 300mm f/2.8 lens will become a slightly slower 600mm f/5.6 lens.

The advantages teleconverters offer are magnification at a much cheaper cost than the price of a comparable telephoto lens, as well as a much lighter, easier piece of equipment to carry. The drawbacks are that teleconverters may decrease the sharpness and overall quality of your photograph, along with the accompanying loss of light. The effects of any camera movement are also magnified.

To insure you achieve the best quality possible, purchase a teleconverter from the same manufacturer of your prime lens because inexpensive teleconverters simply are not as well made. When you are shooting, do not shoot at full aperture, such as f/5.6 with the 300mm lens and a 2.0X converter. If possible, close down to f/8 or even f/11, and you'll have sharper images. This will

RIGHT: Teleconverters are photographic magnifying lenses that many photographers use when their telephoto lens isn't long enough. Matching a teleconverter to your camera and lens is critical to image sharpness.

mean using a slower shutter speed, or increasing your ISO setting to maintain a higher shutter speed.

Many of today's digital cameras have a built-in magnification factor of 1.5, due to the type of image sensor used, which means that the 300mm lens already becomes the equivalent of a 450mm lens, so when a teleconverter is attached, it becomes a 900mm lens!

3

Working with Composition

THE EASIEST way to describe composition is to say that it is simply the way different elements are positioned in your photograph. There are usually numerous ways to do this, and some are naturally more pleasing than others. Those that are the most pleasing to your viewers often tend to follow long-accepted rules from the art world, but conversely, some of the images we like the most break all the rules and show us a totally new perspective.

That's what makes composition one of the most challenging aspects of outdoor photography, and also one of the most important. The light might not be the best, and your color renditions may be off, but a strong composition may actually override these shortcomings.

The best way to learn composition is to learn the established rules and how they can strengthen your photographs, then let your own perspective take over and see what your imagination can do.

Personal Interlude

As my guide and I walked back to camp late one afternoon after a day of filming on Zambia's Luangwa River, I could not help but notice how the sun had turned the waters of a small lagoon brilliant shades of yellow, orange, and even burgundy. I could imagine definite photo possibilities, but we'd already missed the best light so I vowed to return earlier on another afternoon.

A few days later, we did return to the lagoon. It was clear and blisteringly hot, but already I could see the water starting to change color. I set up my camera on a tripod with a 500mm lens, checked exposure, and composed the general image I wanted. Then I left the camera in place and re-joined my guide, who was already sitting quietly in the shade of the nearby trees. I had never before, nor have I since, ever set up a camera like I did there in the African wilderness and then left it unattended, but all around us everything was quiet. Even the small group of hippos resting in a shady corner of the lagoon were silent and motionless in the heat.

BELOW: In this photo of two hippos fighting, the camera had been set in place earlier as the author waited for the late afternoon light. The hippos were a lucky addition at just the right time and moved across the lagoon to exactly the right position.

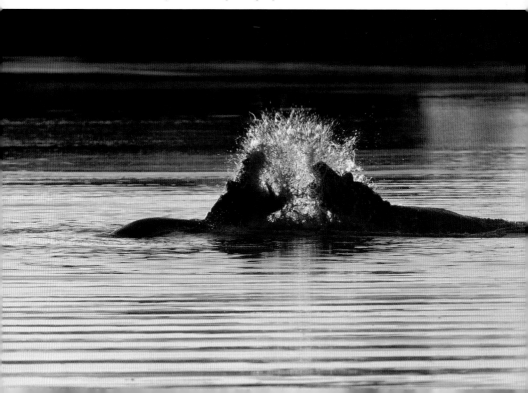

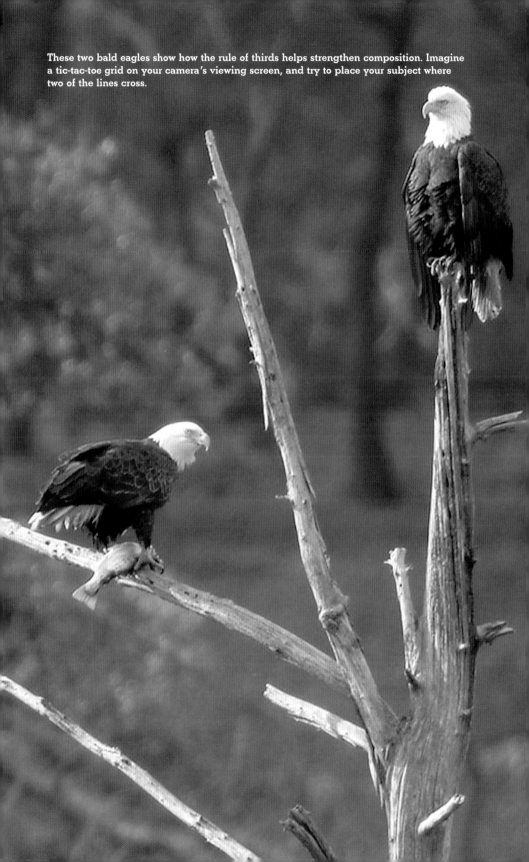

These two bald eagles show how the rule of thirds helps strengthen composition. Imagine a tic-tac-toe grid on your camera's viewing screen, and try to place your subject where two of the lines cross.

Slowly the sun continued its descent toward the distant horizon and as it did, the lagoon's colors changed even more. The light was perfect. I eased back to my camera 40 yards away, and as I did, two of the hippos started bellowing and shoving each other further out into the water. I'd seen such displays many times during my weeks in Zambia, and all I hoped for was that the animals would continue out in front of my lens.

They did. I never moved the camera. As they fought their way into my viewfinder, I simply held down the shutter release button, blazing through a 36-shot roll of film in about seven seconds. Moments later, the hippos declared a truce and returned to their shady corner of the lagoon as if nothing had happened.

Tip #1: Use the Rule of Thirds

Because every photograph has a subject, or center of interest, and usually several additional elements, composition is described as placing that subject in an arrangement with the other elements of the photograph to make it pleasing and easy to understand. One of the easiest, and most universally accepted ways to achieve this in your nature and outdoor photography is by using the rule of thirds.

While looking through your camera's viewfinder, imagine having a tic-tac-toe board superimposed across your viewing screen, with two vertical lines each a third of the way in from the right and left sides of your screen, crossed by two horizontal lines, one a third of the way down from the top and the other a third of the way up from the bottom.

The strongest points in your photograph will be the four places where these lines intersect, so compose your picture with your subject on or very close to one of these intersections. To make your photo stronger, compose so a secondary element or point of interest falls on an opposite intersection.

Surprisingly, the weakest part of a photograph is often the very center, so try to avoid this when composing your image. The rule of thirds, which is believed to have originated with the ancient Greek architects, provides a much more balanced composition and leads the viewer's eye naturally into the picture. Use the rule of thirds with horizon lines, too.

Tip #2: Add a Frame to Create Depth

Framing is one of the easiest and most effective ways to add depth to a photograph, changing it from two to three dimensional, while at the same time helping to emphasize your subject and direct the viewer's eye toward that subject.

Essentially, a frame is some type of foreground object that creates a "frame" around the edges of your photo. Trees with overhanging limbs and branches are among the most popular and common framing devices, and are especially effective when placed along the right or left edge of your photo so the limbs extend across the top. Other plants, flowers, and rocks also succeed because they help define the outdoor environment of your subject. In places like Utah's Arches National Park, for example, the natural stone arches provide excellent frames because they usually cover both sides as well as the top of your photo.

When framing your photo, watch the light carefully, as it may be different than the light on your subject. Spruce and fir trees, for example, with their thick, darker needles, often appear as black silhouettes in contrast to your lighted subject. This

BELOW: Framing your subject can add depth to your image. Frames can be anything natural in the environment, and work best if they are composed on one or both sides of your subject along the edge of your picture.

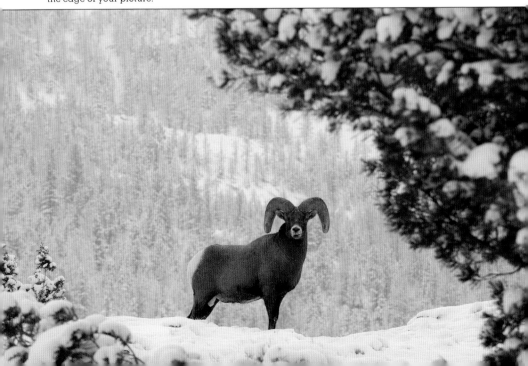

isn't necessarily bad at all, but remember silhouettes will lack any detail. When the sunlight is behind you and illuminating both your frame and subject, make certain your own shadow does not appear in the photo.

Your frame will be nearly always be more effective when it is in sharp focus like your subject, so adjust your f/stop and depth of field accordingly, but don't emphasize your frame so strongly that it detracts from your actual photo subject.

Tip #3: Change the Horizon to Change Moods

Placing the distant horizon line, such as a lakeshore, tree line, or even a sand dune in the middle of your photo so it cuts the picture in half rarely results in a strong image unless you're photographing a reflection in water. Instead, consider the previous rule of thirds when composing the horizon in your photograph.

BELOW: Placing the horizon high or low in your composition can alter the mood of your image. A low horizon here makes the snow geese appear much closer than if the horizon were high in the composition.

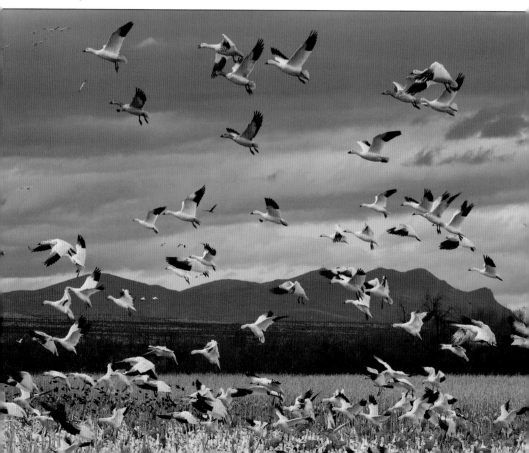

You can dramatically alter the mood of your image by placing the horizon higher or lower, and you can do this simply by changing your camera angle; you don't have to change your position at all. Placing the horizon line closer to the top of your photo will often give the impression your subject is further away, while placing the horizon line closer to the bottom of your photo will make object appear closer.

When you place the horizon higher, make certain you have a strong and uncluttered foreground that won't distract from the image, such as a boat cruising across a lake without anything but water between it and your camera. Consider this composition, also, when you're photographing a field of wildflowers to show its expanse, or when you need to eliminate overcast, featureless skies.

Place the horizon lower in your composition if you have a foreground subject you want to emphasize more strongly. Lowering the horizon can emphasize the sky, so use this composition if you have unusual cloud cover or beautiful sunrise or sunset colors.

Tip #4: Change Angles

The majority of photographs taken today are shot from eye level—the photographer's, not the subject's—and as a result, many of these images are static and uninteresting, and leave the photographer disappointed. With tripods, especially, the

BELOW: Changing your camera angle will also change the mood of your photo. A low camera angle here eliminates most of the background and emphasizes the expression of the Olive Ridley sea turtle coming ashore to lay her eggs.

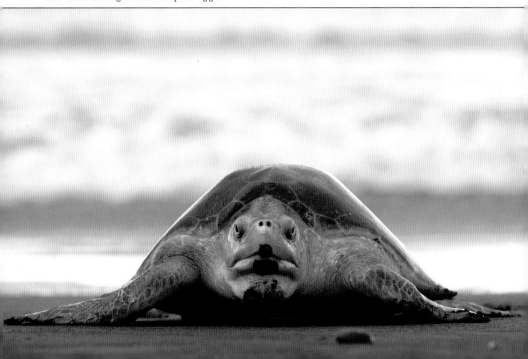

tendency is to extend the legs to full length so the photographer can shoot from a standing position. It's the most comfortable position for the photographer, but it doesn't always give the best point of view.

Always consider changing your camera angle. Experiment by climbing to a slightly higher vantage point (if possible) so you shoot down; or get down on your hands and knees or even your stomach and shoot slightly upward. Try to make changing angles a habit wherever you're shooting.

Shooting from a lower angle or even shooting slightly upward can add drama, impart more immediate action, make some subjects appear larger, and perhaps provide more detail in small plants and flowers. Low-angle shooting is always better with smaller ground-dwelling animals such as rabbits because it provides better detail and makes them appear more natural; shooting at eye level with your subject, regardless of its size, always results in stronger, more powerful images.

Shooting from above is often the best way to shoot large groups of animals because the higher angle will allow you to also include some of their environment. The famous wildebeast migration across the Serengeti, for example, can stretch for miles, and only a higher shooting angle gives a true perspective of how many animals are present.

No matter which angle you shoot from, keep the background clear of unwanted objects. This is particularly important when shooting from a low angle; isolating your subject against a clear, uncluttered sky, such as a successful hunter posing with his trophy deer or an angler with his fish, will show far better detail.

Tip #5: Try a Different Lens

An easy ways to gain a new perspective for your photos is by changing lenses without necessarily changing your shooting position. This will be especially noticeable if you switch to a telephoto lens and use it at a relatively close range. This can be a 70-200mm used at the 200mm focal length, or even a longer 300mm lens.

Longer lenses used at close distances not only produce a tighter image of your subject, but can also blur the background so that practically nothing is recognizable, and when side lighting, not front lighting, is employed, the result can look three-dimensional. There are photographers who use a fast F2.8 300mm telephoto lens like this in the majority of their shooting because of this effect.

Using longer telephotos, such as a 500mm, will definitely isolate smaller portions of a larger scene, especially landscapes, and with the proper composition will give it a stronger impact. If you have such a lens (even a 300mm can be used) try this when you're photographing a mountain range, for example; isolate one or

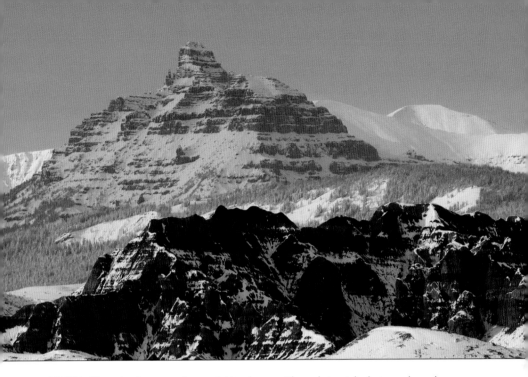

ABOVE: Changing lenses, such as switching from a wide angle to a telephoto, as shown here, provides a completely different composition. A telephoto emphasizes only a portion of your scene and will show more detail.

two dominant peaks rather than shooting the entire wall of peaks with a wide-angle lens. You can achieve the same visual impact shooting longer lenses in meadows filled with wildflowers, streams with rushing water, even tree-filled forests.

When you're composing with a big lens and emphasizing only a small portion of a much larger scene, the same basic rules of composition apply. If the rule of thirds is workable, try it. Look for dramatic colors and even try framing, too.

Tip #6: Let Leading Lines Lead to Your Subject

Leading lines do just what their name implies: lead the viewer to the subject of your photograph. Using leading lines is a time-honored technique among artists to help achieve an impression of depth, and in outdoor, nature, and landscape photography, leading lines also create a three-dimensional effect in your image.

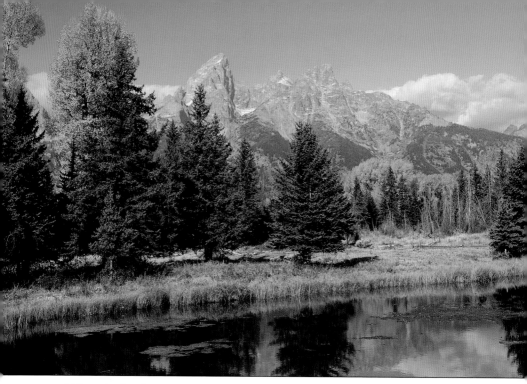

ABOVE: Leading lines are an important compositional tool because they lead the viewer's eye to your center of interest. They do not have to be straight, but they are strongest when they lead in from a lower corner of your photograph.

Examples of leading lines you can use to achieve this include winding waterways and curving tree lines, hiking trails, or even a single fallen log that may lead to a clump of forest flowers. There is no rule that says leading lines have to be curving, either; they can also be straight, horizontal, or vertical. Straight railroad tracks and paved highways can serve as very effective leading lines, for instance, depending on where and what you're filming. For the most part, leading lines are all around you.

Diagonal leading lines tend to be strongest when leading into your photograph from either the lower left or right corners of your image, so composing with them normally requires only a minimum of camera movement or changing your shooting position. Sometimes placing yourself in the middle of your leading line (such as a highway) so it extends across the bottom of your photograph can be effective because it naturally directs the viewer's eye up and into your photograph. Typically, curving leading lines impart a feeling of restfulness, horizontal lines denote strength, and diagonal leading lines convey motion or action.

Because leading lines can be such an important part of your composition, make certain to adjust your depth of field so it is in focus just like your subject. Wide-angle lenses may be a good choice when your subject is smaller and closer to you, while medium-range telephotos may be a better choice when both your leading line and subject are further away.

Tip #7: Composing with Color

Color is just one part of the overall composition of your photograph, but it can be the most important part. That's because color elicits emotions in all of us in real life, including excitement, joy, or drama, and it does the same in photographs. At the same time, effective use of color can lead the viewer directly to the photograph's center of interest.

The different colors in the spectrum are often described as "warm," which include red, orange, yellow, and any mixture of these; and "cool," which include blue, green, violet, and any mixture of these. To strengthen your photograph, compose using both, preferably putting a warm-colored object against a cooler colored background. An example would be photographing a red or orange maple or oak leaf against a blue-sky background.

Another technique is to use what are known as "complementary" colors together, because each will become more vibrant. Red and green are complementary, as are yellow and purple, and blue and orange.

Surprisingly, black can be used to saturate other colors. Compose brightly lit yellow, purple, red, or even white flowers, for example, against a black background of shade and shadows. Small animals like ground squirrels can be photographed

BELOW: Try to use color as part of your overall composition because different colors create different moods. Bright, warm colors usually convey happiness and delight whereas darker, cooler hues may create a more somber, serious mood.

this way; you may even film a white pelican perched on a piling against darker water and see the same effect.

Even when the center of interest in your photograph is small, if it is colorful the viewer's eye will immediately be drawn to it. The color most quickly noticed by the human eye, according to scientists, is a richly saturated hue commonly known as "canary yellow," which is often duplicated in nature by some summer flowers or autumn leaves.

Tip #8: The Eyes Have It

To make any of your wildlife photos stronger and more successful, focus on your subject's eyes. A viewer's attention immediately goes to the eyes, be it a photo of a 550-lb. African lion or a 15-oz. rabbit, so they must be sharp to hold the viewer's attention.

When the eye is sharp, it not only adds credibility and strength to your photo, it will also give the impression the overall image is sharp, even if it isn't. This is often the case with hummingbird photos, in which the wings are usually a blur due to their fast-beating speed. Using a telephoto lens can also result in a partially out-of-focus image, due to the short depth of field, but sharp eyes will save the picture.

BELOW: When photographing birds or wildlife, do your best to make certain the animal's eye, or eyes, are in sharp focus. This will be the first thing your viewer sees, and it makes the entire animal seem to be in focus.

The eye itself can become the center of interest for your photograph, particularly since many wildlife species have very prominent eyes. The eyes of lions and leopards, for example, are yellowish and instantly noticeable, while those of some bird species may be yellow or even red. Other species, such as owls, antelope, bighorn sheep, and even rabbits have very large eyes that simply cannot be ignored in any photograph, so consider making them your focal point.

Start by looking for your subject's eyes even as you begin composing through your viewfinder. If you're shooting in autofocus mode, place at least one of the focusing sensors on an eye, and if you're using manual focus, concentrate on the subject's eye as you turn the lens to sharpen the image.

When natural or artificial light hits the eye of the animal or bird you're photographing, it often results in a small white reflection in the eye known as catchlight. This is highly desirable in your photos as it gives the subject a much more life-like quality. Side-lighting produces the most consistent catchlight but direct light also creates it.

Tip #9: Break the Rules

Although there are many "rules" about how to take a photograph, you should also, from time to time, consider breaking those rules, regardless of whether they're about composition, using light, or choosing a certain shutter speed. Sometimes, the resulting image will have far more impact than if you'd taken it "normally."

The rules of composition probably get broken the most often. While the rule of thirds, for example, should always be considered, there will be occasions when putting the subject in the center of the photo simply looks better to you. If it does, compose with it there and press the shutter.

The same holds true for horizontal and vertical compositions, and even horizon lines. Some obvious vertical shots can be turned into remarkable horizontals, and some horizontals really turn out better as verticals. And sometimes, the best place to put the horizon line is right through the middle of your image. Part of breaking the rules like this is exercising your own imagination.

Fast shutter speeds that stop the action are what we use most often, but perhaps a slow shutter speed will convey action and movement more effectively, even if it does result in a blurry subject. With digital, these types of experiments are easy to do and just as easy to erase, so make it part of your routine to try them.

Photographs are ruled by how you use light, but there is no prescribed rule that forces you to use light a certain way. While early morning and late afternoon

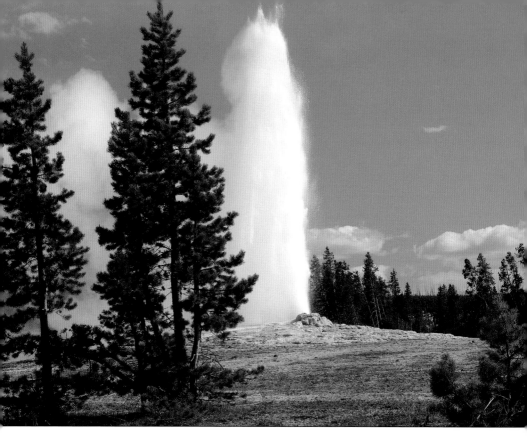

ABOVE: Even though your photo may seem to require either a vertical or horizontal format, break the rules and shoot it the opposite way. Here, the tall trees framing Yellowstone's erupting Old Faithful geyser seem to call for a vertical composition, but horizontal works well, too.

light is definitely softer and easier to work with, limiting yourself to shooting only during these prime hours will cause you to miss a lot of extra shooting time. Go ahead and shoot at midday, and see how your images turn out.

Learning to Read Light

PHOTOGRAPHY IS all about light and how you use it in recording your images. It is certainly one of the three critical elements of your photo—the other two being the subject or center of interest, and your composition of that subject—and many consider it the most important. In fact, the word "photography" derives from two Greek words, *photos*, meaning "light," and *graphos*, which means "to write."

Successful outdoor and nature photographers learn to "see" light, which is to say, they not only understand that light is different in all parts of the world, but that it is constantly changing throughout the day. Morning light in the desert southwest of New Mexico and Utah is very different from the light in Wyoming's Grand Tetons or New York's Adirondacks, for example, even at the same hour.

Light will define the mood of your subject, but your camera won't tell you this; it simply records the amount of light falling on that subject. That's why learning to see the differences in light is so important.

Personal Interlude

Daybreak came early that morning on the South Texas ranch, and if a trophy whitetail deer were going to move through the brush I'd been studying through

my camera lens, it would have to happen soon. It was a cold December morning, but absolutely clear so the light would be changing very quickly as the sun rose. I'd already seen several deer but none had the big antlers I wanted to film.

The light became brighter and the brush took on colors I could not see earlier. Different shades of golds and yellows mixed with greens and browns, giving the spot an almost surreal appearance. Then, silently, suddenly, without warning a tannish brown whitetail doe appeared on the edge of the greenery, stopping momentarily to nibble on fresh leaves. Then she turned her head suddenly to peer behind her, a sure sign other deer were following her.

I held my breath and I'm sure I tightened my hand on the camera. I was in prime big buck country, but as I instantly recognized with the doe, any buck coming through the brush would have to follow her almost step by step for me to have the right lighting and get the portrait type of photograph I wanted. Not only that, because the brush was several feet tall, a buck would practically have to stop in a single specific spot and hold his head up for the light to illuminate his face and antlers.

The doe moved on, out of my view, and seconds later a buck stepped out of the trees and into the brush. He looked up, then put his head down as he followed the doe's scent. He was in rut and trailing her, so he would follow her exact path through the vegetation. In the microsecond I'd seen him before the buck dropped his head, I saw that he was the animal I'd been waiting, hoping, praying for. Now, all he had to do was move about fifteen feet further, stop, and hold up his head.

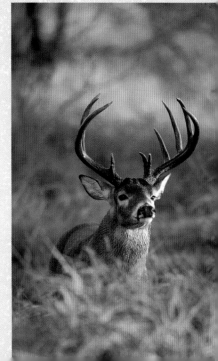

RIGHT: Early morning light on this big whitetail buck preserved detail in the animal's antlers and coat, while the surrounding brush did not have any distracting glare that midday light would produce.

And that's exactly what he did. I'm certain he heard my camera shutter clicking because he stopped several times as he walked slowly through the brush. He was a 12-pointer if you counted the split brow tines, but I never noticed that until later. What I saw through my viewfinder, rather, was a wide, heavy antlered deer in absolutely prime condition, one of the prettiest whitetails I'd ever seen. His darker coat contrasted beautifully against the lighter brush, and sun glinted off his antlers just enough to give them added form.

The entire encounter last less than thirty seconds. The buck put his head down and followed the doe back into the timber. I sat there another hour, long after the sun had washed out the greens and completely eliminated the yellows and golds I'd experienced earlier, but neither deer ever returned.

Tip #1: Shoot Early, Shoot Late

By shooting early in the morning or later in the afternoon, you can take advantage of what professional photographers describe as "perfect light." At these two times of day, especially in the morning when the sun is near the horizon and its light passes through the atmosphere, the light hits molecules and particles of gas, water, dust, smoke, pollen, pollution, and anything else in the air, and becomes

BELOW: Sunlight is much less harsh during early morning and late afternoon hours, which translates into richer, more saturated colors and less contrast and glare.

scattered. Because it scatters, it is not as bright nor as harsh; its overall color is normally warm and rich, often golden. Overall, shadows are less severe, colors are more saturated, and details will be stronger.

A few hours later as the earth's position changes in relation to the sun, sunlight has a shorter distance to travel so it does not have as many particles in its way to scatter it. Thus, it is brighter so the light creates darker shadows and washes out colors, reducing saturation and detail.

To truly see this difference in light, try shooting photos of the same subject, such as a tree in your yard, from the very same angle but at different times of day. Your early morning photos will always have richer colors and better detail than the photos you shoot later in the day.

Late afternoon sunlight is much the same, and although the overall golden hue of the light may be slightly different, saturation and detail will both return. Indeed, thirty to sixty minutes after sunset, during the time known as twilight, you may experience some truly remarkable lighting, especially if the sky has been clear throughout the day.

Tip #2: Choose a Direction

The direction from which light hits your subject has a huge influence on how your photograph will look, and ultimately will determine the success or failure of your image, so consider these directional choices:

Front lighting—when you shoot with the sun behind you so it illuminates the front of your subject—is probably the most commonly used light direction, especially in outdoor and landscape photography. Most shadows disappear, and during early morning or late afternoon shooting, nice detail and color saturation result. One drawback is that photos taken with front lighting, especially in bright light, will often lack depth and appear two-dimensional.

Side lighting—when the sun is to your left or right—will often add the depth and definition you miss from front lighting. Side lighting will create shadows, however, so position yourself, if possible, so the light shines on your subject's face (if you're shooting wildlife, for example), rather than on the back of its head.

Back lighting—in which you're shooting into the light—usually eliminates frontal detail in your subject. Sometimes silhouettes, in which your subject turns completely black, can be dramatic; compose so your subject completely blocks out the sun and is shown against a clear background.

Diffused light—which occurs on cloudy days or during light rain—will usually eliminate shadows and add saturation. The best diffused natural light occurs with

ABOVE: The direction at which the light hits your subject will create different effects. Front light is often flat and lacking detail, while backlighting, shown here with this mule deer, can produce more contrast, if not a complete silhouette.

a light overcast or high clouds, a condition known as "cloudy-bright," because you can shoot as long as it lasts throughout the day.

Tip #3: How to Handle White Balance

White balance is a camera setting that determines how the colors in your photograph will look. Technically, it is a measurement of the temperature of light, and you can adjust it different ways to match your shooting conditions, most often for bright daylight or for cloudy, overcast conditions.

You should pay attention to white balance because what you see with your eyes and how the camera records it are not always the same. That's because the brain simply eliminates some colors but the camera sensor does not. If you've ever tried to take a photograph of a gorgeous reddish-orange sunset, for example, but gotten only a white sky in your camera LCD screen, you know this is true.

ABOVE: The white balance setting on your camera is a measurement of the light, and different settings produce different exposures. Many photographers set the white balance on "cloudy" because it helps saturate colors, especially on bright days.

Digital cameras offer several white balance settings, the most important of which to outdoor nature photographers are Automatic, Daylight, Cloudy, and Shade. Each setting records your image with a different light temperature, and thus a different overall color shade. Fortunately, the automatic (A) setting on today's latest cameras is quite accurate, especially if your subject is well lit by sunlight. Without getting technical, and for reference, the camera will use a temperature of 5,500° Kelvin on this automatic setting. If you have doubts, use the automatic setting, at least when you first get started.

In the cloudy setting, often represented by a cloud icon, the camera will change to a higher temperature reference, such as 6,500 Kelvin, in an attempt to warm the photo by removing some of the blue coloration. Many outdoor photographers set their white balance to cloudy and leave it there, so they will automatically get warmer images. In bright sunlight conditions, colors will often be richer and more saturated with a cloudy setting, too.

The shade setting will usually warm your photograph even more, using a temperature reference of perhaps 7,500 Kelvin. This setting is most effective when your subject is actually in the shade.

Other settings include Flash, Florescent, and Tungsten, all of which refer to artificial lighting and are not regularly used by outdoor nature photographers.

Tip #4: Working in Low Light

Unfortunately for wildlife and outdoor photographers, many species of animals are most active during low-light conditions, either very early in the morning or very late in the day. Weather conditions, particularly a heavy overcast, can also take away light. Fortunately, there are still ways to take outstanding photographs during these periods.

The very first thing to do is increase your camera's ISO setting. This changes the camera sensor's sensitivity and response to the available light, thus enabling you to record the image. The newest digital cameras have remarkable ISO ranges that far out-distance older film cameras and even early digital models, and give you several additional f/stops or shutter speeds with which to shoot.

Arbitrarily dialing up the ISO, however, such as from a normal 200 to 5,000 or higher, for example, is not the best way to do it, because each camera model's sensitivity is different. Increasing the ISO will at some point result in a shift in the color rendition as well as an increase in the amount of grain, or "noise," that shows in your photo; what you must determine is at what setting this begins to occur. In earlier digital cameras, these shifts became apparent as low as ISO 800 but today they're generally much higher.

The easiest way to do this is to shoot the same low-light scene numerous times, increasing your ISO setting with each exposure. Then, with the images downloaded

BELOW: Low-light conditions, such as dawn here at Oxbow Bend in Grand Teton National Park, usually require longer exposure times. Increasing your camera's ISO setting will allow you to use a faster shutter speed.

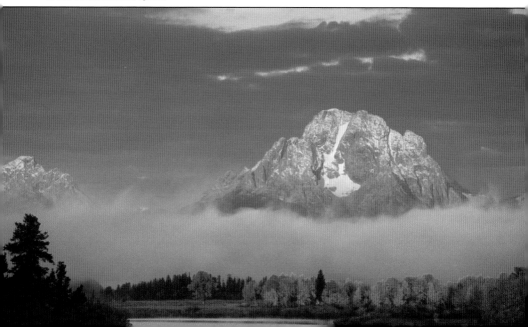

onto your computer, study each one until you really begin to see the grain or color change. This ISO number should then become your reference point; you can go that high, but don't go further.

Low-light shooting almost always requires a tripod, even with the ISO dialed higher, and certainly if you use a shutter speed of 1/30 of a second or slower. If you can shoot the scene with a faster lens that has a larger aperture, such as f/2.8, that will also help, since it will gather more available light than a slower lens.

Finally, consider bracketing your shots with different shutter speeds or apertures. Sometimes, when you do get a color shift, it will be surprisingly attractive.

Tip #5: Conquering Bright Sand and Snow

If you rely strictly on your camera's light meter when you're photographing on the beach or in bright snow, you will nearly always underexpose the image, meaning both the snow and sand will appear a very unnatural gray in your final photo.

Technically, this occurs because the meters in virtually all digital cameras are set to record the light in an "average" scene, in which approximately 13 to 18 percent of the light hitting the subject is reflected back to your eyes, and to your camera. Even in bright snow, your camera will only record this 13 to 18 percent reflection, so you have to adjust your camera settings accordingly. Film cameras are usually set to record 18 percent; digital cameras closer to 13 percent.

What you must do is increase exposure at least one full f/stop, and usually 1 1/2 stops. While it seems you should do exactly the opposite, remember that by increasing the amount of light going through your lens and being recorded on the image sensor, you're actually correcting the camera rather than monitoring the brightness of the snow.

Because the actual brightness of snow and sand can vary during the day, shoot different exposures using a technique known as "bracketing." This means shooting several images with different exposures. While overexposing by 1 1/2 f/stops will usually get you very close to the correct exposure, shoot another photo overexposing a full two f/stops, and then a third shot overexposing just 1/2 f/stop.

You can do this easily on digital cameras by using the exposure compensation button, or by switching to the manual adjustment mode. Consider different angles, as well, especially side lighting that will add texture and detail to the sand or snow.

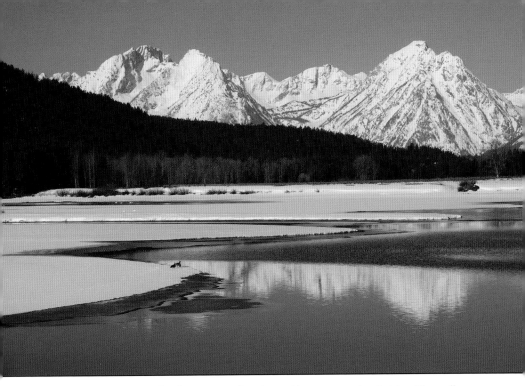

ABOVE: When shooting bright scenes, such as those with snow or sand, polarizing filters will help reduce the glare. Because the brightness will fool your camera's light meter, you should also increase exposure by at one to two full f/stops.

Tip #6: Take Advantage of Bad Weather

Both summer and winter storms that bring rain and snow can offer some unusual and often rewarding photo opportunities. Two major concerns are the amount of available light, and keeping your equipment dry.

Good chances for images may be present before a storm actually hits. Wildlife species know the weather will be changing long before we see it happening, and they're often out feeding heavily, sometimes as much as twenty-four hours before the storm. In the case of an approaching snowstorm, wildlife may be feeding in bright sunshine rather than only at dawn and dusk.

As a storm approaches, your photographic light often becomes softer and with less contrast, due to high cloud cover. The closer the storm comes, however, the darker the sky will turn. With changing light like this, carefully study your exposures through your LCD screen and histogram, because not only does the light change rapidly, it continually diminishes. Consider changing your shooting mode to either shutter or aperture priority, or even manual, rather than auto or program mode, so you can make adjustments faster and easier, over ruling your camera's meter if necessary.

ABOVE: Bad weather conditions, such as during an actual snowfall, can produce drama not seen in fair weather. Keep your equipment protected, but explore the possibilities when the weather is bad.

When shooting in rain, slow your shutter speed to 1/4 or 1/2 of a second so the falling drops will show as long streaks in your picture. Slightly overexposing through your camera's exposure compensation button, will produce better images, too.

When shooting in falling snow, do not use any type of flash, since it will illuminate the flakes as big white spots all over your image. Instead, use the exposure compensation adjustment to bracket your exposures. In contrast to shooting slower speeds in rain for those long streaks of water, shots with falling snow are generally stronger with a faster shutter that shows the snow as smaller flakes.

Weatherproof covers for cameras and lenses are available from large photography supply houses, and are easy to use during inclement weather. They're made for different length lenses, from short wide angles to long telephotos, and cover both the camera and the lens you're using.

Tip #7: Creating Silhouettes

Silhouette photographs, in which your subject appears completely dark and without detail, provide a creative way to use light when it is directly behind your subject, especially between about 10 a.m.–4 p.m. when light is the harshest and

produces the most contrast. Silhouettes can be taken morning, noon, and late afternoon, however.

They can be created by positioning your subject against a much lighter background. Photos of hikers and climbers silhouetted against a distant snowy mountain panorama are a good example of this type of image.

To create a silhouette, position your subject so it directly blocks out the sun. For the strongest impact, make certain as much of your subject as possible is positioned against a clear background, not lost in the clutter of trees or rocks. Using a lower camera angle often solves this.

Bracketing your exposures will help insure you get the type of photo you want. Meter on your silhouetted subject—it won't necessarily appear black in your

viewfinder—and then take additional photos underexposing the scene, which will insure your subject turns black. This may also help turn an otherwise bland, whitish sky blue.

Using different filters will also add impact and color to the sky. Special effects color filters, such as those produced by Cokin and other companies, can change

BELOW: Silhouettes, in which your subject turns dark and loses detail, are created when you shoot into the sun. Use your subject to complete block the sun and keep your background clear for a full silhouette.

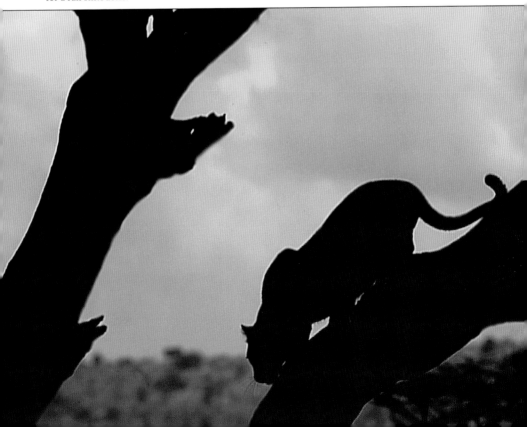

the sky to orange, red, blue, or even brown, depending on your color choice. Underexposing the image will increase the saturation of these colors.

Silhouettes of wildlife can be especially impressive when taken late in the afternoon against a naturally occurring yellowish-reddish-orange sky. When the sun is low enough and shows as a large reddish ball, it can be included in your image for an even more dramatic effect. Again, bracket several different exposures, but this time include both one and two stop overexposures as well as underexposures.

Tip #8: Stretching Perfect Light

Even though the "perfect light" of early morning only lasts a short time, you can "stretch" perfect light by using various techniques. Sports and news photographers have to use these techniques every day, and they are easily applied to outdoor and nature photography.

Concentrate on color—Although bright light under a clear sky will lighten, or decrease saturation in colors, you can sometimes minimize this by composing with contrasting colors in your image. Try to have brighter-colored subjects on lighter backgrounds. Place reds and yellows against a lighter browns or greens, for example. Underexposing your image 1/2 or even one full f/stop, especially with bright subjects, is always worth trying.

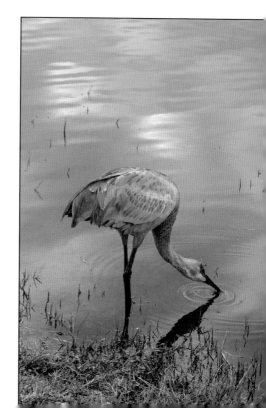

RIGHT: You can "stretch" perfect light with several techniques, such as composing very tight on your subject, avoiding harsh contrasts, and even underexposing by a full f/stop if you have a bright subject.

Shoot tight—Use a longer telephoto lens to isolate your subject and eliminate background brightness and contrast. Don't hesitate to use a telephoto when you're already close to your subject; with side-lighting and a large f/stop to further reduce depth-of-field, you can achieve a three-dimensional effect.

Avoid harsh light contrasts—In scenics that include both land and sky, consider eliminating the sky, because of the f/stop difference between the two. Framing with a tree or other object that eliminates much of the sky may be a possibility. Stay away from darker shadows, even in the background, so change your direction and angle of shooting.

Use a polarizing filter—Polarizers aren't just for eliminating glare on water or emphasizing white clouds in a blue sky; overall, they help eliminate glare and improve color saturation anywhere, except in shade.

Consider fill lighting—Use a flash to complement natural light outdoors, but take care not to over-ride the natural colors. On most accessory dedicated flash units, which synchronize with your camera, you can adjust the amount of light output, so dial it down slightly just to reduce shadows.

Tip #9: Adding Fill-In Flash

When your subject is in shadow, or the overall light is dim, you can add artificial light by using a flash unit. Many DSLR cameras, compacts, and even cell phone cameras have built-in flash units, but an auxiliary flash unit is more powerful and will also let you control both the intensity and direction of its light.

Virtually all major DSLR camera manufacturers offer auxiliary flash units, and other manufacturers sell universal flash units; all of them fit on top of the camera, sliding into a connection known as a hot shoe. These types of flashes feature several different adjustments to control the amount of light they produce, but their most endearing feature is known as TTL, or through-the-lens metering, in which the flash unit synchronizes with the camera to automatically produce an accurate exposure without any calculations on your part.

When you purchase an auxiliary flash, spend the extra money to purchase a synch cord, as well. This cord will fit into the hot shoe and allow you to hold the flash away from the camera while you shoot. A flash mounted on top of your camera will produce direct front lighting, which usually results in flat, one-dimensional images. Just by holding the flash to one side with the synch cord, you can create a type of side lighting that will produce much better detail and definition. It will also allow you to illuminate only a selected portion of your image.

These flash units allow you to change the intensity level with each shot. If your subject is really in deep shadow or slightly further away, increase the light intensity to a setting of +1 or possibly even +2. If your subject is closer, decrease the exposure to create a more normal appearance.

Tip #10: Saturate Your Sunsets

Every photographer loves to shoot sunrises and sunsets, but all too often, their shots don't record what they actually saw. Several issues cause problems, including location, timing, and exposure.

Whenever possible, scout a photo location in advance for either sunrise or sunset. Composition is extremely important, and virtually all truly memorable sunrise and sunset photos include a center of interest beyond the sun itself. Typically, because of the strong backlighting, these are silhouetted foreground objects that can be trees, ocean piers, even wildlife.

Finding a suitable location in advance also allows you to get your timing correct. Sunrises and sunsets do not last long—when the bottom edge of the sun

ABOVE: You can add saturation to the warm colors in sunrises and sunsets by setting the white balance on your camera to the Kelvin scale (K) and dialing up the temperature reading to as much as 10,000. Try different temperature settings to see which you like best.

touches the horizon, you have about a minute to shoot before it disappears below the horizon—and the light will be changing constantly during this sixty seconds. Try to be in your location and ready to shoot a half hour or so in advance.

Shoot different exposures—a technique known as bracketing—to make certain you capture the scene the way you want it. As a starting point, use a meter reading of the sky that does not include the sun, then shoot both under and over that exposure. When you include the sun in your image, use a longer telephoto to increase its size but study your exposures carefully, since they will change when you change lenses.

Adjust your white balance setting to "cloudy" or "overcast" to add warmth to your exposures, and spend more time underexposing than overexposing. Then, consider changing the white balance again to the Kelvin setting and dial the color temperature up to about 10,000 for a completely different rendition of the yellows, oranges and reds.

Tip #11: Redirecting Light

Sometimes you may want to redirect light into a certain part of your photograph that is hidden in shadow or which needs a little more detail and color that added

light will provide. You can do this with a reflector, either one you purchase or make yourself.

Commercial silver-sided reflectors are available in various sizes from leading photographic supply stores, and generally fold into convenient, easy to carry packages. They're lightweight, inexpensive, and are used by professionals in all types of photography. In outdoor and nature work, reflectors are most useful when photographing small, stationary subjects like flowers, plants, and insects.

If light is hitting your subject from the right side and creating shadows on the left for example, you may be able to eliminate those shadows or at least make them less noticeable, by placing your reflector behind your subject on the left side. Light bounces, or reflects, back to illuminate the left side of your subject. By moving the reflector, you can change the amount of light or even the area being lit. The downside of using reflectors is that it often takes a second person to hold them in position while you shoot.

A smaller reflector may be all you require, and you can make one by purchasing two sheets of white foam core from a hobby or art supply shop, and taping them together along one edge. This allows you to open them as a V so you may be able to balance them on the ground by your subject. You can cut them to any size you prefer, but most photographers like 12" by 12" or even smaller for ease of transport.

BELOW: You can redirect light on your subject and add detail by using a reflector, either one you purchase from a photo supply store, or by making one yourself with small sheets of white foam core, available from hobby and art stores. Photo by Valerie Price Seals.

5

Pressing the Shutter

WHEN YOU press the shutter to take a photograph, your camera's sensor records the light on its pixels to create your image, but your picture-taking should not end there. There are many ways to improve how your camera records that image, but you have instruct it what to do.

That was the case with film photography in the past, but you still had to have your film developed before you actually knew how your changed worked. The beauty of digital technology is that you can see your changes immediately, and continue to make adjustments as you want to. The important thing to realize is that you have this capability to take advantage of it

Making exposure changes digitally is easy, too. Normally, little more is required than turning a dial or pressing a button. Virtually everything will be explained in your camera's instruction manual, and often shown with diagrams. Don't try to learn everything about your camera all at once. Choose an option and play with it until you become familiar with what it does.

Personal Interlude

During the last two weeks of November each year, I spend several hours each day high on one of the mountain ridges in northwestern Wyoming filming bighorn sheep that have moved down to their winter range. Normally, this is the best opportunity to see and photograph the rams fighting for herd dominance and breeding rights, but one year the rams simply did not seem that interested in fighting. Hour after hour, day after day, I crouched beside rocks or underneath trees with cameras ready but all the rams did was walk around and either graze or mingle nonchalantly among themselves.

November 30 that year dawned perfectly clear and bitterly cold, and even as I began my vigil shortly after dawn, I could sense a change among the rams. Four of the largest not only remained very close together but also continually used different body language, such as nuzzling or touching one another with a front leg, to communicate different messages. Then a fifth big ram that had thus far stayed away from these four joined them.

It certainly appeared that the famous lunging, horn-smashing fighting was imminent, and anxiously I watched as the magic golden light of early morning gave way to bright, harsh late-morning light. Light snow added to the brightness, and

BELOW: To capture action like these two lunging bighorn rams, a fast shutter speed is required. Most of today's DSLR cameras have shutter speeds of over 1/1,000th of a second, so use them if you can match the speed with the correct aperture.

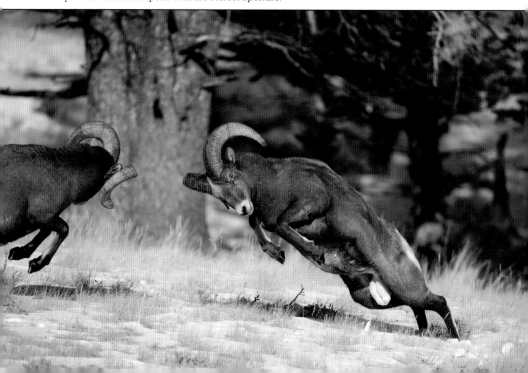

even with a shutter speed of 1/1,000th of a second, I was still getting an aperture reading of f/11.

Suddenly, at exactly 11 a.m. I heard the hard, loud and unmistakable clack! of horns hitting each other, but it wasn't from the rams out in the open in front of me. These two males had picked an absolutely ideal location, in a well-lit but slightly shaded area along a treeline fifty yards away. With my 500mm lens and tripod over my shoulder, I ran to within twenty yards of the rams and started shooting. The light, although bright, was certainly workable, and I reset my camera to 1/2,000th second at f/4. I didn't need a lot of depth of field, only a fast shutter to freeze the animals in mid-air as they lunged at each other. Rarely, if ever, do I shoot anything that fast, but that day the available light allowed me to do it.

In only a few moments it was over, as one of the rams simply turned away from his adversary and started grazing again. I think they may have smashed into each other a total of three times, and I was lucky enough to film part of it. The victorious ram walked down to the others and one by one met their challenges. In an hour the fighting I'd been waiting to film for two weeks ended as abruptly as it had started, as all five rams walked away, their fierce behavior of just moments earlier seemingly completely forgotten.

Tip #1: Choosing a File Format

Unless you adjust your camera differently, it will record your images in a digital file format known as JPEG. In JPEG, the camera does its own editing of the scene in a compressed format, and much of the original information captured when you pressed the shutter is discarded and lost forever. If you then want to do additional editing in the computer, you're at a disadvantage because so much original information is not there.

A better way to shoot your images is in a capture mode known as RAW. In this process, every bit of information in your picture is kept for you to work with; this is how nearly all professional photographers work. Your camera will have a simple adjustment that allows you to shoot in this format.

While it is advantageous to have the complete file of your image available for your processing, opening these RAW files requires a raw file conversion software program in addition to your regular processing program, such as Adobe Photoshop. Most of these conversion software programs are camera-specific, and can be purchased and downloaded from the internet.

RAW files, because none of the original information captured has been discarded, are much larger than JPEG files, so you will also need larger memory

ABOVE: Most professional photographers shoot in the RAW file format because it preserves all the pixel information that was original recorded in the image. When you shoot in the JPEG format, the camera edits the pixel information and much of that information is lost.

cards. When you open your raw image, you'll see a different picture, one that shows the complete range of tones. More importantly, you have total freedom to edit and correct any part of the image.

Tip #2: Shoot, Shoot, Shoot!

One of the cardinal rules among professional photographers is to always shoot a lot of images when on any assignment, more images than will ever be published for that particular assignment. Sports photographers, especially, may take more than 1,000 photos a day at an event.

Thanks to the digital revolution, shooting a lot of pictures can, and should be, part of your photographic routine. It may take more editing time, but the more you shoot, the better your chances are of capturing just the image you want. With digital, too, the advantage is that it doesn't cost anymore to take fifty pictures than it does to take just one, and everything you don't like can simply be discarded with the push of a button.

All DSLR cameras today have a shooting mode selector setting that offers single shot, continuous shooting, and high speed continuous shooting. Set your camera for the high speed shooting—you can still shoot single images with this setting—and train yourself to shoot in bursts of three or four shots before stopping. What you'll soon discover is that while you just took three photos of the same subject, one will nearly always be better than the others.

It may be slightly sharper, or have a tiny change in composition that looks better. If you're photographing a person, a burst of three or four shots virtually guarantees you'll catch your subject with eyes open, not blinking; if you're shooting a moving subject, one of your images will be focused better, and very likely will capture the defining moment of behavior.

Tip #3: Working with Shutter Speeds and F/stops

Many amateurs and newcomers to digital photography set their cameras on automatic or program shooting modes, then rarely think about two of the most important factors in picture-taking, shutter speeds and f/stops.

BELOW: Don't stop shooting after taking just one photo. Keep shooting, because one of your images will invariably be better than the others. Digital makes this easier than ever before, since you can discard unwanted photos immediately.

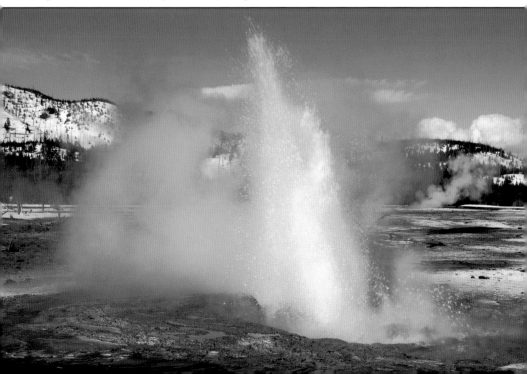

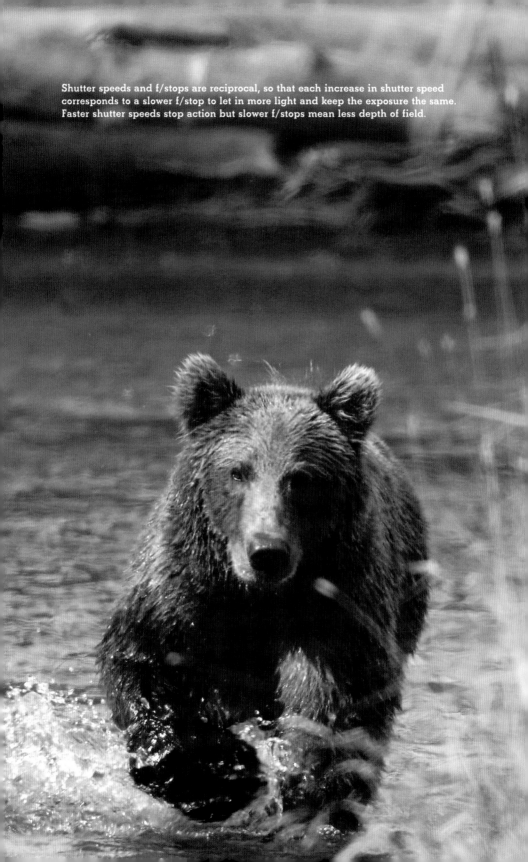

Shutter speeds and f/stops are reciprocal, so that each increase in shutter speed corresponds to a slower f/stop to let in more light and keep the exposure the same. Faster shutter speeds stop action but slower f/stops mean less depth of field.

Shutter speed is the speed at which your camera takes a picture; this may range from several seconds to faster than 1/8,000th of a second. Basic shutter speeds are set in increments to double as you get faster, or half as you get slower, such as 1/30th, 1/60th, 1/125th, 1/250th, etc. Outdoor and wildlife photographers most often use shutter speeds between 1/30th and 1/500th of a second, and many use 1/250th as a basic shutter speed setting. Today's DSLR cameras have an adjustment, generally designated as S, that allows you to choose a particular shutter speed; when you do, the camera automatically chooses the appropriate f/stop for the correct exposure.

An f/stop represents the size of the aperture opening of your lens, and is expressed in numbers like f/2.8, f/3.5, f/5.6, f/8, f/11, f/16, and f/22 (newer high-end digital cameras will also add intermediate f/stops like f/6.3, etc.,). The lower the f/stop number, like f/2.8, the larger the aperture opening and thus the more light can come through the lens to the camera's light sensor. These are known as "fast" lenses. Conversely, the higher the f/stop, the less light can come through the lens. Each f/stop in descending order allows twice as much light through the lens as the previous f/stop; f/3.5, for example, lets in twice as much light as f/5.6, and so on.

The key to using your shutter speeds and f/stops is understanding that they are reciprocal. One f/stop change equals one shutter speed change. If your exposure is 1/60th at f/11, for example, you will get the same exposure at 1/125th of a second at f/8, or 1/30th at f/16.

Fast shutter speeds are needed to "freeze" running animals or flying birds, but you lose depth of field (range of sharpness) with the corresponding wider aperture. Smaller apertures provide the greatest depth of field in your images, but you lose shutter speed. Knowing how these two key elements of photography interact is critical to correctly exposing an image to achieve the results you want.

Tip #4: Changing the ISO Rating for More Speed

In digital cameras the ISO setting is a measurement of the camera sensor's sensitivity to light. It's an extremely important setting in that it determines how your photograph is exposed. You can increase the ISO setting when you need a faster shutter speed or a smaller f/stop for greater depth of field, but changing must be done with care.

The ISO number originally comes from the film industry and stands for International Organization of Standards. Older photographers will remember this as the ASA number before it was changed to ISO. It is a measurement of a film's

sensitivity to light; the higher the number, the more sensitive that film was to light. Generally, wildlife photographers used films rated between 50 and about 400, although much more sensitive films were available.

In digital photography, the same principle applies in general with the camera's sensor. It is not uniform, however, because as technology improves, different camera models have different sized sensors; DSLR cameras have larger sensors, for example, than compact point-and-shoot cameras, and thus are more sensitive to light. Newer digital cameras have improved sensors over older models, too. The result is a greater range of sensitivity.

For most digital shooting with a DSLR, an ISO setting of 200 is a good starting point that will produce sharp, colorful images. By increasing this setting to 400, which many outdoor photographers use as their regular setting, you gain one shutter speed increase. The latest cameras allow ISO settings of over 6,000 now, but your very best quality images will still come with lower ISO settings.

By increasing the ISO setting, your image will gradually begin to lose quality. An overall graininess, known in digital terms as "noise," will appear throughout your image and a finished print looks as if it has grains of sand in it. Your photograph won't be as sharp, nor will the color be as saturated.

BELOW: This cow moose and calf were photographed at dusk in very low light, but increasing ISO rating, which changed the sensor's sensitivity to light, allowed for an exposure that captured the animals crossing the stream.

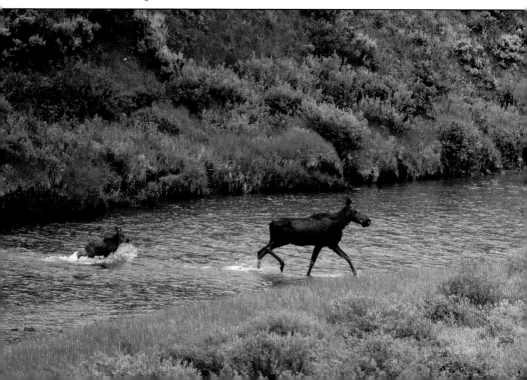

You need to know approximately at what setting your image begins to lose its quality. Experiment by shooting the same scene in the same light but increasing the ISO with each shot. With many DSLR cameras today you should be able to go at least as high as 1,250 or 1,600 before you run into problems; the noise and loss of color will be very noticeable on your computer screen.

Tip #5: Using the Magic Button

Most DSLR cameras today have a special adjustment technically known as exposure compensation, but it is also sometimes called the "magic button." What it does is allow you to easily add or decrease your exposure setting in increments of about 1/3 of a stop. Using the magic button eliminates having to readjust your shutter speed and aperture settings; you just dial in a positive or negative amount depending on what you believe your photo needs. You can do it in program mode, too.

Using the exposure compensation adjustment allows you to vary your exposure as much as several f/stops for either over- or underexposure, so you really have a lot of room to work with, especially in difficult conditions. The changes come in

BELOW: DSLR cameras have a "magic button," or exposure compensation adjustment, that lets you increase or decrease exposure in small adjustments quickly and easily by turning a dial. Look at your camera's LCD viewing screen after you shoot and make the adjustments necessary.

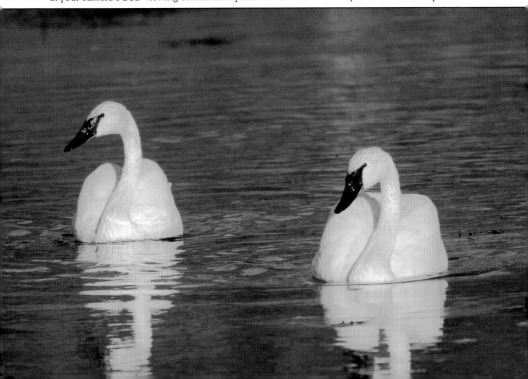

your shutter speed, but they're very small changes that you can't get by directly changing the shutter speed yourself.

Instances where you might use exposure compensation include shooting a white egret in direct light where you may want to decrease your exposure part of an f/stop to insure you capture detail in the bird's feathers; or in a low light situation in which just a little added exposure will render the scene the way the want it.

Remember to return the magic button setting to o when you stop shooting a particular scene or before you turn your camera off after a day of shooting because exposure compensation is not reset when the camera is turned off. In case you do forget, the setting will be displayed in both the viewfinder as well as on the camera control panel.

Tip #6: Getting It Sharp

Unless you have a special reason for using manual focus, you should use your camera's autofocus system to keep your images sharp, at least until you become more experienced using your camera and lenses. Today's latest DSLR cameras provide excellent autofocus technology, which even the most experienced pros use when filming fast-moving subjects.

BELOW: Today's cameras offer excellent autofocusing systems for shooting both stationary as well as moving subjects. Make sure your focusing sensor is locked on your subject and it appears clear through your viewfinder when you press the shutter.

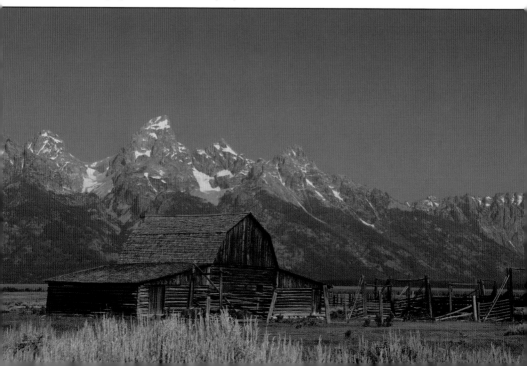

Most autofocusing systems offer two modes, depending on what you're filming. For moving subjects, these are known as "continuous servo" for Nikon cameras, and "A1 servo" on Canon cameras; for stationary subjects, these settings are named "single servo" and "one shot," respectively. These are settings easily set on your camera, regardless of the brand. For wildlife and nature photographers, the most useful settings are for moving subjects.

Autofocus systems include sensors that appear on your viewing screen when you look through the eyepiece. There are usually different options available, with varying numbers of sensors, and you can change their location on your screen and thus have more composition options.

Autofocus is activated by placing one or more sensors on your subject and depressing the shutter halfway down. Be careful when you select a group of sensors and put them on your subject, because they will focus on whatever object is closest to the camera; everything in that same plane will be sharp. Concentrating the sensors on the body of a large animal like an elk, for example, may leave the animal's head and antlers slightly out of focus, since they may be in a different plane, even though they're only a few inches further away.

Using a single focusing sensor may be a better choice because you can place it on the animal's head or even on its eye. Using a higher f/stop number (such as f/22 or f/16) for increased depth of field will also help. Using multiple sensors can be particularly helpful when shooting smaller moving objects such as birds.

As your subject moves, keep your shutter pressed halfway down so the camera will maintain focus, as some autofocus systems can actually predict where your subject will be. When you see the composition you like, take the picture by fully depressing the shutter.

Tip #7: How to Pan Moving Subjects

Panning is an effective and easy to use focusing technique when filming moving subjects, such as flying birds and running deer. Instead of keeping your camera stationary and hoping to capture one perfectly sharp, perfectly composed image, you follow your subject by moving, or panning, your camera with it.

The advantage of panning like this is that it allows your camera more time to focus. Depending on the effect you want to achieve, you can also use a slower shutter speed, although a faster shutter speed will increase your chances of getting a sharp image. Panning will create a blurry background, which, when your image is perfectly in focus, will also help create a three-dimensional effect showing motion.

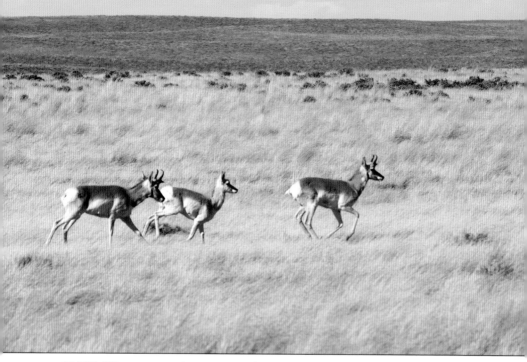

ABOVE: When you pan with your camera while following a moving subject, using a slower shutter speed will cause the foreground and background to be blurry and thus increase the appearance of movement. Take several shots to insure your focus will be sharp.

If you can see your subject approaching, pick it up in your camera and depress your shutter button halfway to activate autofocus. Continue to keep the shutter partially depressed as you follow the subject in your viewfinder, and when you see the composition or angle you like, start shooting by fully depressing the shutter. Don't stop with just a single image, and do not stop panning the camera; continue to follow your subject, even after you've stopped shooting. This is known as follow-through, the same process used by shotgun shooters, passing quarterbacks, and championship golfers.

Sometimes you may know in advance where you subject is going to be so you can determine when you want to take your photos. Pre-focus on this particular spot—think of a butterfly flitting from flower to flower—and, keeping your shutter partially depressed, start following your subject until it gets to your chosen location, then start shooting.

Tip #8: Choose Your Exposure

Exposure, of course, is one of the key components to every photograph, and choosing how you want your image to look will always be one of your most important decisions. The majority of today's digital cameras offer several different

exposure modes from which to choose, and because each has a special purpose, it's important to understand when to use each one. Changing from one mode to another usually only involves turning a dial on your camera body.

In the program or auto mode, the camera makes the complete exposure decision for you, choosing an aperture and f/stop combination that may or may not be appropriate for the scene you're shooting. The time to use the program mode is when you're first becoming familiar with a new camera.

The shutter priority mode lets you choose the shutter speed you want, and the camera automatically picks the proper f/stop to give the correct exposure. Many photographers shoot shutter priority much of the time, and often at a faster speed (1/250 and faster) to make certain they stop action, but don't forget that when the light changes, your f/stop will, too, and it may limit your depth of field.

Other photographers prefer the aperture priority mode, in which they choose an f/stop and the camera matches it with the correct shutter speed. This is an excellent choice for a lot of outdoor shooting, especially landscape work, since by choosing an f/stop like f/16 or f/22, you insure both sharpness and depth of field. If you also need a faster shutter, increase the ISO setting.

BELOW: Today's DSLR cameras offer several exposure modes, including auto or program, shutter priority, and aperture priority. You can choose which one, and the camera will set a correct exposure for you, by matching your shutter speed with the right f/stop, the right shutter speed with your f/stop, or choose both.

In the manual mode setting, you choose both the f/stop and aperture. This allows you the most flexibility for exposure control and experimentation. You can take a basic exposure reading through the camera in any of the other modes, then change to manual to tweak it as you wish.

Tip #9: Expose for the Center of Interest

When your scene includes a lot of highlights (bright areas) as well as a lot of shadows (dark areas), choose your center of interest and expose specifically for it. This may cause the shadows to go darker or even turn black, or your highlight areas to get lighter, but if your center of interest is strong enough and properly exposed, your photo can still succeed.

Try re-composing your photo to minimize highlights or shadows so your center of interest does not have to compete with them. Your camera's meter will also do a better job of exposing the overall image.

If you have to choose between exposing for highlights or shadows, expose for the highlights. Shadows are supposed to be dark and so having detail in them is

BELOW: In the majority of your shooting you should expose for the center of interest in your photograph. This is what you are emphasizing in your image, and what viewers will look at first.

not always needed, but detail is critical for highlights and cannot be added later through computer enhancement work.

You can minimize the f/stop differences between the highlights and shadows in a photo by shooting early in the morning or later in the afternoon when the sun is not as bright. A polarizing filer and a neutral density filter can also help even the exposure between the two extremes.

These types of problems are often encountered when photographing moving water in streams and waterfalls. Study the scene carefully and compose it different ways, emphasizing the highlights in one image and the shadows in another to see which works best. Bracket your exposures for each, as well.

Tip #10: Study Your Histogram

Each time you press the shutter with your DSLR, a chart known as a histogram is produced. It is a visual display of how the light, dark, and midtone ranges were recorded in your exposure, and it is something you should learn to study constantly when you're shooting.

Later, when you're correcting your photos on the computer, you'll find an adjustable histogram in levels, one of the first Photoshop tools many photographers use. When you're in the field shooting however, the histogram will tell you instantly if you need to correct your exposure for better results.

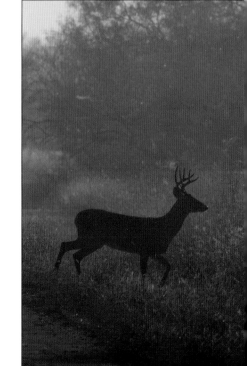

RIGHT: Digital cameras produce a histogram of each image you shoot, which shows how you exposed the shot. The tonal range of shadows, mid-tones, and highlights is produced on a graph that tells you exactly where you need to make corrections.

In the histogram, blacks and darker tones are represented on the left, highlights and whites on the right side, and midtones in the middle. For an average tonal scene, you want the tones to appear in the histogram as a bell curve in the center, not concentrated on either edge.

If your image is composed primarily of lighter highlights, the curve will be more to the right on the histogram, and if your image has more darker tones and shadows, the curve will be more on the left. Thus, a histogram is important in telling you what you recorded with your f/stop, shutter speed, and ISO selection, and just as importantly, it will tell you what you did not record.

The easiest way to move the curve more toward the middle is by using the exposure compensation adjustment, or magic button, and increasing or decreasing your exposure in small increments as needed.

You can normally access the histogram through your camera's playback mode in the menu and program it to appear on your LCD by pressing one edge of the control button. Several histogram display options may be available, including a smaller thumbnail of the photo with the histogram or a full screen histogram. Consult your camera's instruction book for specific instructions.

Tip #11: Maximizing Depth of Field

Depth of field is the zone of sharpness in your photograph including both in front of and behind your subject, and it can vary greatly in size. Depth of field is usually most desirable in landscape photos, but it is not necessarily always needed or wanted in wildlife images. As long as you understand what depth of field is, you can control it to some extend as you're shooting.

Several factors influence and determine depth of field in every photograph, including the focal length of the lens you're using, your distance from your subject, and the f/stop setting on your camera. Depth of field increases with smaller f/stops; and also when you decrease the focal length of your lens. Overall, it can range from literally less than one inch to more than 100 yards, depending on the above variables.

For more depth of field, shoot at f/16 and f/22 when possible, even if it means using a slower shutter speed, regardless of the lens you're using. Try changing lenses, too, such as dropping down from a 200mm to perhaps a 50mm, if the change works for you. You can move further away from your subject, and you'll also get more of the foreground and background sharp.

The majority of DSLR cameras today have what is known as a depth of field preview button, usually located near the lens itself. Normally you look through

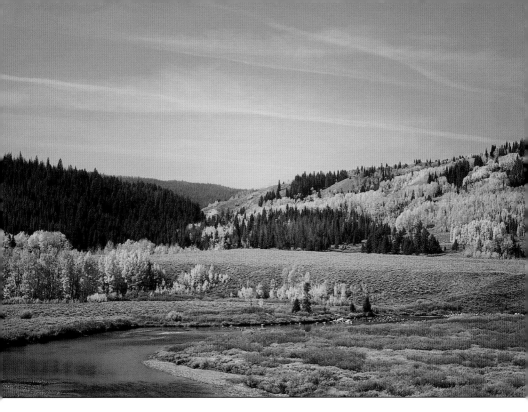

Depth of field is the zone of sharpness from near to far in your photograph. You can control this by shooting at smaller f/stops like f/16 and f/22 whenever possible, even though it will also mean using a slower shutter speed.

your viewfinder with the lens wide open, which gives the brightest scene, but pressing the preview button stops the lens down to the aperture it will use and the viewing screen is darker. It takes some practice to distinguish what the depth of field actually is on this darker screen but fulltime pros use this button religiously. You can make it easier by putting your coat or a dark cloth over your head and the camera to block out extra light.

⑥ Special Wildlife Techniques

FOR YEARS, one of the largest industries in the world has been travel and tourism, and wildlife watching has been the fastest-growing segment of that industry.

Wildlife photography, especially since the introduction of digital cameras, has certainly contributed to that growth.

Much of the appeal of wildlife photography comes from the sheer beauty of capturing images of creatures in their own environment, and this can range from birds around your backyard feeder to bighorn sheep and elk in the Rocky Mountains to lions and elephants in Africa. There are challenges to capturing certain types of behavior, but there is no denying the excitement any photographer, amateur or professional, feels when he does capture it.

As you grow in photography and become more experienced, you will undoubtedly develop your own techniques and style of shooting, but in the beginning, study the established techniques, learn how different species behave, and spend as much time shooting as you can.

Personal Interlude

Very early in the filming of my African book, *Valley of the Big Cats*, I witnessed a defining moment in leopard behavior, in which a cat, hidden from view, would attempt to ambush a guinea fowl walking past to its nightly roosting area. A flock of the birds, after dusting themselves, would come by in single file, but the instant the leopard moved, the guinea would take wing. To be successful, the leopard had to not only leap high enough and fast enough to get one, it also had to leap ahead of the bird in order to intercept it.

Over my weeks of filming, I probably watched this particular hunting activity four or five different times, and each time the leopard had failed to bring down a bird. Late one afternoon as my guide and I watched a leopard hide in a shallow ditch beside the path the guinea fowl would come, we eased up to within about fifteen feet of the cat and began to wait.

Two hundred yards away, we could see a large flock of guinea fowl dusting themselves, but my shooting light was disappearing quickly. I adjusted the camera and flash, then braced it on my knee as we sat in the vehicle. Soon, bird after bird began coming down their little path, completely unaware of the leopard's presence, and not giving my guide or me a single glance.

Within minutes, it was too dark to distinguish individual guinea fowl, but suddenly I felt, rather than actually saw, the leopard leap, and I pressed the shutter purely by reflex. When I looked at the camera's LCD screen, I couldn't believe the

RIGHT: Wildlife photography is seldom predictable. The author waited nearly two hours in silence to capture this instant of a leopard leaping and catching a guinea fowl in the darkness.

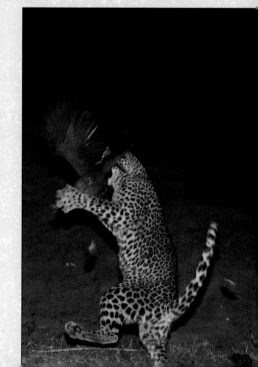

photo. Somehow I had caught the leopard in mid-air with feathers flying as the guinea was hit. We had waited motionless and in silence nearly two hours, and the action had lasted just a fraction of a second. It was the first time my guide had ever seen a leopard actually get a guinea, too, and he was as excited as I was.

Tip #1: Do Your Homework First

One of the most important aspects of successful wildlife photography does not pertain to cameras and lenses at all, but rather, planning your time afield and studying the birds or animals you want to photograph. Much of wildlife and nature photography is based on timing, and to take the best images you have to be on location at the correct time. In essence, you need to become a naturalist as well as a photographer.

If you enjoy photographing birds, for example, you can actually gain a lot of insight just by watching them at a feeder in your yard. Many will always land on the same limb or branch, then hop to the feeder for their seed; to get a natural picture, you can focus on that limb, not the feeder, and wait for the birds to come to you.

BELOW: Wildlife lives by its own schedule, so it's important to study animal habits as much as possible in order to be at the right location at the right time to improve your chances of success as much as possible.

Certainly, you need to be where the wildlife is at the optimum times, and there are many sources for this information. National parks, national wildlife refuges, and national seashores are among the very best and most popular places to film birds and wildlife, and all have websites that will provide optimum viewing and filming times. Guidebooks will offer a wealth of information. Later, telephone calls to the specific locations will provide more specific details you will need to plan your trip.

In parks where wildlife is accustomed to human presence, large game will often come to the same fields and meadows to feed at predictable times, and by using the same approach trails. If you can position yourself along one of those trails, rather than in the field, you'll definitely take more interesting pictures. Once you're in the field, accept the fact that you won't see nearly all the species that see you, so part of your homework needs to be learning to identify the "signs" wildlife leaves, including not only tracks and scat but also worn trails, freshly pawed dirt or snow, and even rubbed and clawed tree trunks.

It takes time and experience to put all this together, but by doing as much study and homework as possible beforehand, you can put yourself into a better opportunity to get the images you want.

Tip #2: Spot Wildlife Like a Guide

Being able to see wildife is a critical part of wildlife photography, and it must be learned before you'll truly get the images you want. It can be frustrating, especially when you travel to a different type of terrain, such as from the rolling meadows in the South to the high forests of the Rocky Mountains. Guides and local residents always seem to see animals you never realized were present.

To become a good wildlife spotter, don't concentrate on terrain close to you. Train yourself to look much further away, even several miles away, depending on where you are. A casual glance will instantly show you anything within a hundred yards or so, but most wild game will be further, particularly when you're not shooting in a park or refuge where wildlife is accustomed to human presence.

Look for something different in its surroundings. Usually, you'll first notice a color change, such as light brown against darker black (perhaps an elk or deer against the darker timber); or a spot of white against darker blue or green (such as a duck or goose on the far side of the lake). As you become more familiar with both the terrain you're in as well as the wildlife that inhabits that terrain, color differences will become the first identifying features your eyes notice.

ABOVE: Although this coyote blends in well with its surroundings, its movement made it easier to see. Movement, location, and color are three key ingredients to spotting wildlife.

Look for different shapes that don't match their surroundings, such as horizonal lines in a vertical scene. Most cover like trees and plants grow vertically, so a horizontal line can easily be the top of the body of a larger mammal. If you see something like this, look next for movement. Even the best guides get fooled by distant boulders and stumps, but neither one of them move, so don't hesitate to study them.

Professional guides also know where to look because they're familiar with the terrain, and one important location is always a transition zone where the terrain or the cover changes. Examples include where a treeline edges a meadow; the bases of steeper cliffs that meet flatter ground; where rocky terrain meets grass or other vegetation; and certainly anywhere a stream or pond cuts through forest or field.

Tip #3: Filming from a Vehicle

In some areas, especially national parks and national wildlife refuges, filming from your vehicle may not just be the best way to capture good wildlife images, it may be the only way. Most national wildlife refuges, for example, offer carefully designed automobile tour routes that may wind for several miles through

prime wildlife habitat and all but guarantee sightings and photo opportunities.

When you're using any type of telephoto lens under these conditions, always use some type of support to insure image sharpness. The two most common types are beanbags and specially made window mounts. Beanbags are the least expensive, easiest to use, and provide excellent support when draped over a door, window, or even the hood of your vehicle, in case you do get out. Rest the barrel of your lens, not just the lens shade, on the bag. If you are shooting across the hood of your vehicle, consider using a second beanbag under your camera body for added support.

Beanbags are little more than canvas or cloth bags, approximately 12 to 15 inches in length, and filled with small dried beans or even sand. One end of the bag is sewed closed, the other sealed with Velcro or a zipper so it can be emptied and folded flat for packing and travel, then filled on site. You can make your own beanbag by cutting off the lower leg of an old pair of bluejeans.

Window mounts are available from several dealers, and, as their name implies, generally mount on the vehicle window or door. Some feature a mounting bracket for a tripod head, to which you can leave your camera and lens attached for continuous shooting. These types of mounts are often favored by

BELOW: These two bull elk were filmed with the camera braced on the hood of the author's vehicle. Wildlife is often easier to approach from a vehicle, and in some areas, may be the only way to approach them.

video photographers because they allow smooth, fluid side-to-side panning with the camera. By contrast, lens movement on a beanbag is limited without re-arranging the bag itself.

When filming from a vehicle, approach your subject slowly and don't stop suddenly. When you're in position, turn of the ignition to eliminate engine vibration.

Tip #4: Get Close by Stalking

Stalking both birds and larger wildlife on foot is a commonly practiced technique wildlife photographers use to get closer to their subjects, but it must be done with care and patience to be successful. If there is one cardinal rule that defines stalking, it is to move very slowly and usually with long pauses.

Rest assured your subject nearly always knows of your presence, regardless of whether it pays any particular attention to you. That's why moving slowly—taking a few steps at a time, then stopping for a minute or longer before moving again—is so important. It allows the bird or animal to become accustomed to you. The closer you approach, the more important your pauses become.

Do not walk straight to your subject, and don't look at it. Angle slightly toward it, and be quiet. If you're with another photographer, don't talk. Individual animals are often easier to approach, as herds and flocks frequently have one or more lookouts watching for danger. Elk herds have "lead cows," for example, and Canadian geese have "guards."

Have your camera adjusted and your exposure confirmed, and take pictures periodically during your stalk. If you're using a big lens mounted on a tripod, don't have it on your shoulder, but rather, carry it in front of you so you can shoot faster.

Watch your subject for signs of alarm. Nearly all wildlife has an invisible distance of safety and tolerance, beyond which you won't be allowed to approach. As you do get closer, birds will start to take steps, flex their wings, or turn and face into the wind, while some animals will shake their tails while staring directly at you or begin to paw and prance. If you see these signals, stop instantly and don't look at them.

Crawling is sometimes a better approach for bird photos. Move slowly, keep your camera in front of you, and if you see any indications of nervousness, stop.

Stalking wildlife on foot should always be done slowly and quietly, and generally at an angle rather than directly at your subject. Take shots along the way in case the animal runs away.

Tip #5: The Blinder the Better

A blind, or "hide," as the Europeans call them, can be anything that hides you from the subject you want to photograph. It can range from something as simple as a camouflaged net that drapes over you and your camera, to a small but permanently carpeted and heated room in the woods like those found on some South Texas deer hunting ranches. The most popular photography blinds are portable, easily assembled tent-like blinds, available from a number of photography and sporting goods supply outlets.

Blinds are definitely worth considering if you will be filming in a particular location for a period of time, and no matter which type of blind you use, it will be most effective when it literally becomes part of the environment. Some birds and animals are extremely tolerant of blinds while others may take several days to accept them. If you use a purchased blind, put it in place quietly, preferably when your subjects are not around, and add natural materials like logs, limbs, or grasses to make it look more natural. Then leave and don't return for a couple of days.

Most purchased blinds are similar to camping tents in that they feature a lightweight frame and a nylon or canvas covering. They're essentially designed for one photographer and his gear so they're fairly small and lightweight, but they're also very effective because they can be transported easily and quickly set in place.

BELOW: Hiding in a blind is a good way to obtain unusual wildlife behavior photos. A blind should blend in with its surroundings as much as possible, and possibly left unattended for a day or so to let wildlife become accustomed to it.

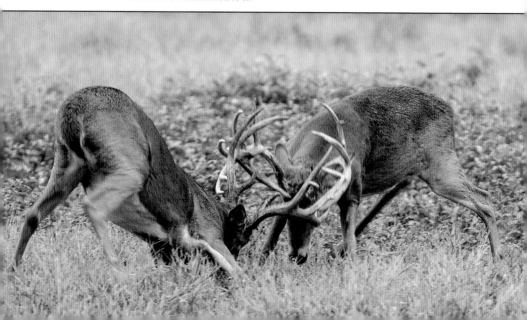

Do some scouting before you set up any blind. Key places to consider include near the edges of ponds, marshes, and meadows, as well as along game trails. Even though your blind is designed to conceal you, try to conceal the blind itself. Pay attention to the angle of the sun and how it will move during the day, because to really be effective, you should plan to remain in your blind for several hours at a time.

Include a small stool or chair to sit on while inside your blind, and use a tripod to support your camera. Most commercial blinds have small slits or openings through which to shoot while still concealing the lens.

Tip #6: Start with Backyard Birds

More photographers probably begin by shooting birds in their own backyards than with any other subject. After all, birds are plentiful and cooperative, and luring them into camera range is easy; overall, they're probably America's favorite photo subjects. Normally, all it takes is putting up a simple feeder, then setting up your camera and shooting.

BELOW: Photographing birds in your backyard provides an excellent introduction to wildlife photography. Putting up a simple feeder practically guarantees a steady stream of photo subjects like this finch.

Your photographs will be stronger if the bird is pictured on a limb or branch, rather than perched on the feeder itself. Fortunately, birds often land first on a nearby limb before hopping to the feeder, and most will use the same spot time after time. When you set up your feeder, try to place it where one of these resting limbs is available.

Check the background of this resting limb, as well, to make sure it is free from wires, houses, and other background clutter.

Once birds begin visiting your feeder, which normally does not take more than a few hours at most, you can actually sit outside with your camera and wait for them. At first, your presence will spook them, but before long they'll be returning. Once they do, keep your movements to a minimum to avoid spooking them again.

Using a tripod will help minimize your camera movement. After you've identified their resting limb, you can compose and pre-focus on that spot, then wait for a bird to literally fly right into your picture. Using longer telephotos, even as big as 500mm, will not only allow you to remain slightly further away but also compose very tightly. Once birds know your feeder is available, they will visit throughout the day.

Sunflower seeds are a universally favorite food of many birds, but putting up a second feeder with a different type of food will usually attract different species, adding to your photo possibilities.

Tip #7: Capturing Birds in Flight

If birds are among the most popular subjects to photograph, then capturing them in flight is among the most challenging aspects of bird photography. Progressing from filming relatively stationary birds to moving ones is only natural, however, and several techniques can be used to make it a little easier.

On a positive note, you'll quickly recognize not all birds fly at breakneck speed. Some larger birds, such as egrets, herons, pelicans, and gulls, fly relatively slowly and thus are better subjects to start filming than some of the smaller species that fly much faster.

Learning to anticipate when a bird is about to take off or land is also important, so take advantage of the fact birds take off and land into the wind. To film waterfowl taking off, for example, focus on the bird as you slowly approach from downwind. The closer you get, the more nervous the bird will become, often fidgeting or swimming in slow circles, but always turning back into the wind. When it does go airborne, it will do so facing you.

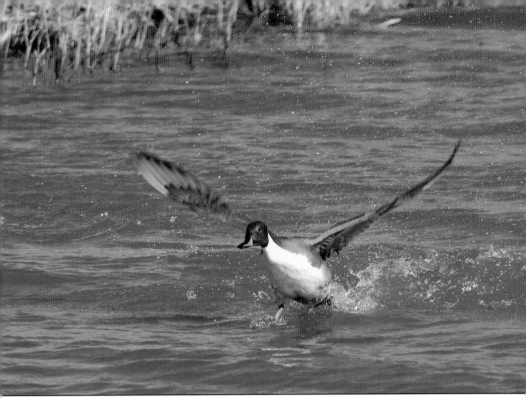

This pintail taking flight was photographed by approaching the bird slowly from upwind and pre-focusing a 70-200mm telephoto lens on the duck's head. Birds will exhibit some signs of nervousness just before takeoff so you can be prepared to shoot.

Always use auto focus instead of manual focus, because it's faster. Set your auto focusing sensor or sensors in the center of your frame to begin; later, as your skill improves, you can move them up or down or to one side for different compositions. Once your lens locks on a bird and has it in focus, keep the shutter at least partially depressed so the lens will continue to focus as you follow the flight.

Set your shutter speed for at least 1/500 of a second or faster, especially for takeoffs. For some waterfowl, a shutter speed of 1/1,000 second may be needed to stop the action. When filming against a clear sky, you may need to underexpose so set your exposure compensation for -.7 or even -1 to avoid overexposing.

Tip #8: Include the Environment

The temptation to get closer and closer to the bird or animal you're photographing so it fills your viewfinder is one every cameraman faces on each trip afield. Indeed, getting closer is a part of the challenge many photographers enjoy as much as focusing and pressing the shutter.

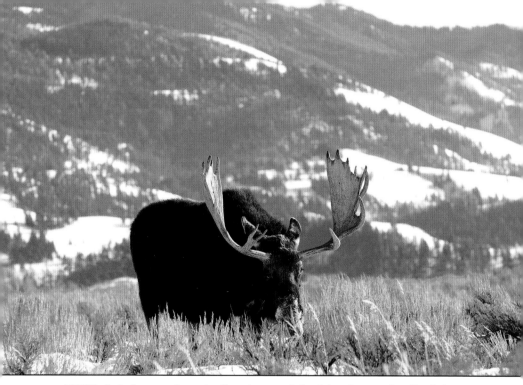

ABOVE: Including part of an animal's environment helps define the animal itself and often strengthens the image. Here, a bull moose is feeding in sage brush where the snow is not as deep as on the forested mountainside behind him.

Another challenge that can be easier to meet, and which can often results in truly amazing images, is including part of your subject's environment in your image. This can include additional tree branches, marshland, or even sand dunes for various species of birds; and meadows, waterways, forest, or rocky cliffs for animals. A popular, often published example of this type of photo is the famous Moulton barn in Grand Teton National Park with the majestic high peaks of the Teton Range in the background; imagine how bland a photo like this would be without that wall of mountains. In fact, you've likely never seen this photograph without the mountains.

In short, including part of the environment with your subject adds to the overall story your picture tells. Instantly, anyone looking at your photograph gets a clear understanding of where and how your subject lives. Generally, adding some of the environment usually just means having more foreground or more background around your subject.

Including part of the environment requires more consideration for composition, since your subject will usually be smaller in the photograph. You can do this is by using a different lens that does not have as much telephoto power. With a zoom lens all you have to do is zoom to a shorter (more wide angle) focal length without ever moving to a different position. If you've been using a 70-200mm

telephoto, for instance, back it down to the wider 70mm focal length and slowly zoom in until you see the composition you like. Your overall center of interest does not need to change. What does change is the perspective of how you present them.

Tip #9: Make a Wildlife Portrait

Taking portraits of wildlife, be it of a mammal, bird, or even an insect, should become part of your wildlife photography routine, if for no other reasons than it is fun, adds variety to your shooting, and can be extremely challenging. Wildlife portraits differ from many other types of wildlife images in that they typically show little background or environment, but rather, emphasize your subject or perhaps only part of it.

These types of photos, however, do not have to end with a head-and-shoulders composition only; with large animals your photo may have wider interest if you include the chest and front legs, and at times, you may actually want to include the entire body. When shooting smaller creatures, especially small birds, a full-body composition is often more interesting unless you're trying to emphasize a particular feature like head coloration, bill shape, or a perhaps a fish, insect, or other food the bird is eating.

BELOW: Shooting wildlife portraits should become part of your filming routine. Portraits do not have to be limited to the head and shoulders, however, and can include much of the body, as well.

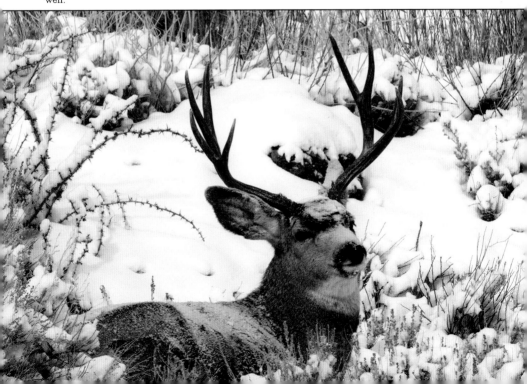

Shooting at eye level with your subject is important in this type of photography and should be your first goal, since camera angle can change your meaning dramatically. High angles, for example, (when you're shooting down on your subject) nearly always lose their semblance of portraiture, while lower camera angles (shooting upward) can result in strong images but still lack impact.

All wildlife exhibits different facial and body language, so look for some different type of expression like this as you're filming. The element of surprise or alarm is probably the most common factor photographers see, and will certainly change any creature's expression; this could be freezing in position, definitive ear movement, mouth opening, hoof pawing, even emitting a warning signal. If an animal is feeding, you may be able to press the shutter as it pauses with a mouth full of stems or leaves, so be aware of these opportunities and try to capture them.

Seldom will you be using a wide angle or even a normal lens for this type of photography because your full emphasis should be a tight image of your subject.

Tip #10: Capturing Action and Defining Moments

Photographers use the term "defining moments" to describe a special moment of behavior that defines that bird or animal. It can be the instant two whitetail bucks

BELOW: Defining moments are special moments of wildlife behavior that are characteristic to that bird or animal, and capturing them in photographs requires studying your subject's behavior and being ready to shoot when it happens.

clash antlers in fighting for dominance, or the second a great blue heron spears a fish. Usually, but not always, this behavior lasts only a few seconds.

As you progress deeper and deeper into wildlife and outdoor photography, your goal should be not just learning to recognize these defining moments when they occur, but also capturing them. To do that you have to be patient, and you also have to be prepared.

The first key is knowing the habits of the species you're filming so you can actually anticipate a defining moment, and yes, you can do this when you understand the creature you're filming. In some instances, they will repeat defining moments at various intervals so you may get a second chance to film it, but not always. Consider a nesting osprey with newly hatched young in the nest; the bird will leave every few minutes to catch fish for them, and when it returns, it will always land into the wind, and also spread its wings to slow its flight. Its legs, with talons holding the fish, will be outstretched downward toward the nest. That's a defining moment, and it's not hard to capture, as long as you're in the right place at the right time.

How you photograph the approaching osprey is the same way to capture any other type of defining moment. Keep looking through the viewfinder, your lens focused on the nest so you're ready to shoot instantly. Use a fast shutter speed because you are filming movement, and take at least one photo just to check your exposure setting. Then, as the osprey comes into view, start shooting; don't just go for one image but instead, shoot the entire sequence of the bird as it lands. One of those images will be your defining moment.

By setting up and being ready like this, you increase your opportunities to capture other types of action and defining moments you might not be expecting. Always look for movement and action, and be ready when that defining moment occurs.

Tip #11: Extending Your Flash Range

One way to extend and increase your flash range when photographing birds or other small subjects with a telephoto lens is to attach a fresnel lens to your external flash unit. These lightweight and inexpensive accessories concentrate the light from your flash into a much smaller area further away from your camera and produce the equivalent of two to perhaps even three full f/stops more light. Essentially, flash extenders like this are not suitable for use with lenses of less than 300mm focal length, which is why they are ideal for filming small subjects that may be in shade or simply need some extra illumination.

Several firms produce these products and they're available at large photo supply houses, typically under the name of flash extenders or fresnel lenses. Some

ABOVE: You can extend the range of your flash by attaching a fresnel lens in front of it. These inexpensive accessories concentrate your flash and allow you to light subjects as much as thirty feet away.

are designed to fit specific flash units, while others are held in place with Velcro. They are fairly fragile, and care must be taken not to scratch or damage the thin fresnel lens. Do not attach one to your flash until you're ready to use it, and when you do attach it, make certain it is properly aligned with your camera lens. The average cost of a flash extender is around $40.

Exposure is taken care of automatically by your TTL (through the lens) metering system. Consider experimenting with the power settings on your flash to obtain the exposure you want, and you should do this, since you're lighting a small subject further away than normal. You can also mount flash extenders on remote, off-camera flash units to concentrate even more light on a faraway subject.

Tip #12: Remember, They're Wild

As your excitement and enthusiasm with wildlife photography increases, you will probably experience the desire to get closer . . . and closer . . . to your subject, trying to completely fill the viewfinder with the animal you're shooting. Just remember, even in crowded national parks they are still wild creatures and as such, no matter how docile and uninterested they may appear to be of your presence, you cannot predict their behavior.

Obviously, some, like grizzly bears, are universally recognized as dangerous, and in parks like Yellowstone, Grand Teton, and Glacier where they are most

Always remember that no matter how docile or bored wildlife may appear, they're still wild, unpredictable animals that can be very dangerous. Some species, such as grizzlies, require extreme caution when you're photographing.

often seen, rangers do their best to keep photographers at a safe distance when an animal is located. In Alaska, backcountry guides carry rifles to protect their photographer clients because they understand the unpredictability factor. Professional photographers take those wonderful close-ups with long telephoto lenses that allow them to stay further away.

Bears are not the only dangerous creatures you'll find in some of the Western parks, however. Bison are probably even more unpredictable than bears, and certainly much faster than they appear. Every year, rangers tell stories about tourists who walk up to a grazing bison and try to put a child on its back for a photo, with severe injury or death often the result. Moose, too, are extremely dangerous, even though they often seem to tolerate crowds of sightseers and photographers. Female moose protecting their young calves are probably more dangerous than grizzlies in those situations.

Common sense should be your teacher, and caution be your guide. As a photographer, you must remember you are a visitor in the animal's domain, and while you certainly intend to do no harm, the animal does not recognize that. Study the behavior patterns of the wildlife you want to photograph, and if it means staying further away, do it.

⑦
Special Landscape Techniques

LANDSCAPE PHOTOGRAPHY, perhaps more than any other type of outdoor photography, requires the photographer to create his own personal interpretation of the scene before him. There is no specific right or wrong way to photograph a majestic range of snow-capped peaks or a rolling meadow filled with wildflowers.

Photographing landscapes encourages you to learn to "see" a particular image in the scene before you. It is easy to fall into the habit of shooting a photograph from the same spot everyone else uses; indeed, in certain places trails, boardwalks, and highway pullouts encourage this. All it takes to get a different perspective may be to step a few feet to one side or the other, or to kneel instead of stand when you press the shutter.

At the same time, certain time-proven techniques are always worth considering and will help you progress and truly do learn to see the photos around you.

Personal Interlude

The coarse, black sand beach of Ostional National Wildlife Refuge along the Pacific coast of Costa Rica attracts few photographers during the year, due largely to its remoteness, difficulty of access, and lack of facilities. The exceptions are a few days during the full moon in August and again in September when thousands of Olive Ridley sea turtles come ashore to lay their eggs. The Ostional beach is one of just nine places in the world where the turtles come ashore simultaneously.

The difficulties of filming the arribada (arrival) of the turtles became evident to me immediately during my first walk along the beach. It was September, and if it wasn't actually raining, the dark skies looked as if they were about to at any moment. If the Ridleys came ashore at night, photography would not be possible because no flash photos were allowed. Finally, I would be in Ostional only four days; if the turtles did not come ashore during that time, I would miss them.

A few individual turtles came ashore my first night, and, led by a local guide with a red-filtered flashlight, I watched as the prehistoric reptiles laboriously made their way out of the surf and up the sand where they dug pits and then deposited their eggs. I tried shooting a few photos using the guide's flashlight, but the results weren't satisfactory; I needed the turtles to come ashore during the day.

The next night, more Ridleys came ashore during another rainstorm. They plowed up the beach for hundreds of yards pulling themselves through the sand, and even at daybreak when I walked along the beach, a few were still making their way back to the surf. I was in the midst of one of nature's most remarkable occurrences, and had yet to shoot any real images.

On my final day in Ostional, the sun broke through for a few hours in the morning, and as I walked the beach still another time, I could see turtles bobbing in the surf. I sat on a log and watched as one or two left the water and started coming toward me. A local resident predicted the arribada would begin in earnest later that afternoon.

As the hours passed and morning turned into afternoon, the sky grew darker, the wind increased, and I heard thunder in the distance. The turtles seemed to be concentrating near a portion of the beach that would be difficult for me to get to, and with the approaching storm, I limited myself to one camera with a 3oomm telephoto lens and a tripod.

As the first drops of rain fell, the turtles began coming ashore. It started with perhaps a dozen, then another dozen and another, until I was seeing hundreds of turtles crowding through the sand and hundreds more waiting behind them. By now it was pouring rain and I could hardly focus the lens in the gray light. I shielded

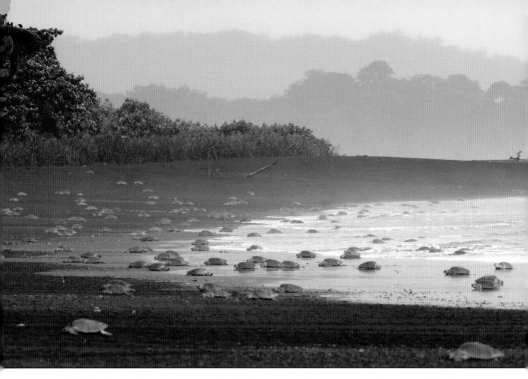

ABOVE: The author managed to take this photograph of sea turtles coming ashore to lay their eggs just as a heavy thunderstorm hit. He had waited four days for the arrival of the turtles, and had less than fifteen minutes to photograph.

the camera and lens with my raincoat, so I was totally soaked, and finally, with lightning flashing around me and the rain falling in torrents, I gave up and ran to shelter. I had waited four days and gotten less than fifteen minutes to photograph, one of the most difficult and discouraging trips of my entire career.

Tip #1: Balance Your Landscape

One technique that can add strength and meaning to your landscape images is by including two or more different points of interest in your composition. The key is insuring all of the points of interest are related so they complement each other.

Another way to think of balancing the landscape is to compose your photo so it has a foreground, a middle, and a background. Consider an image, for example, that has dramatic mountain peaks as a background, a lake or river in the middle ground, and logs, rocks, or flowers along the shoreline in the foreground.

Adding foreground to your landscapes is easy, because it can be practically anything, such as rocks, trees, plants, wildlife, or even the edge of a cliff or canyon. Framing devices can also serve as a foreground and one of your centers of interest.

The point of interest in the middle of your photo can be the primary center of interest for your entire image, or it can serve as a secondary point of interest that

relates to both the foreground and background. Adding something colorful here is a good technique that will help draw the viewer's attention to it.

Your background point of interest will generally need to be larger in your composition in order to help balance the foreground and middle ground. Ideally, your foreground will lead the viewer right into the middle of your image, which in turn will lead the viewer to the background.

Again, the absolute key is make certain all three centers of interest relate to each other and contribute to the overall strength of your image. Utilizing this technique is much easier than it sounds, and with practice will become a natural part of your landscape photography.

Tip #2: Follow The 1/3–2/3 Rule

When you're shooting landscapes, particularly big scenes, striving for maximum depth of field will usually be one of your primary concerns. As described earlier in Pressing the Shutter, depth of field is that zone of sharpness from the front of your photograph to the distant background.

In landscape photography, using the 1/3–2/3 rule will always give you an idea of what your depth of field will be: from your point of focus, approximately 1/3 of

BELOW: Balancing your landscape photograph so that it has a foreground, middle, and background, leads to a stronger image. Often, this means having two or more primary points of interest, such as here with the Grand Tetons, the small section of the Snake River, and the reddish willows in the foreground.

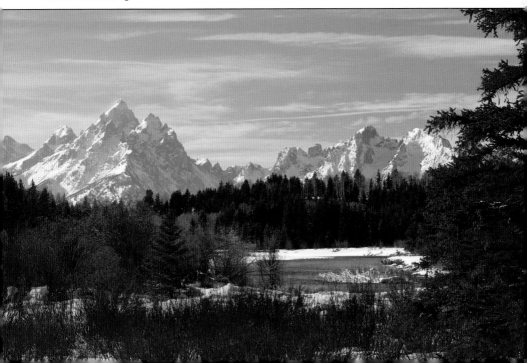

With the 1/3–2/3 rule, you can know that when shooting at f/16, your depth of field will include everything approximately one third of the way in front of your point of focus and two thirds of the way behind it.

the distance in front of it and 2/3 of the distance behind it will be in focus at f/16. Thus, you do not necessarily need to focus on infinity to make certain that distant mountain is sharp.

A more accurate way to insure maximum depth of field is by focusing on the hyperfocal point, in which everything from about half this distance all the way to infinity will be sharp. Below is a chart of hyperfocal points you can copy and keep with you when you're shooting landscapes. It is only for wide-angle–type, and notice how this distance changes with your f/stop as well as the size of your lens.

Aperture	15mm	17mm	24mm	28mm	35mm
f/11	3.5 ft	4.5 ft	9 ft	12 ft	19 ft
f/16	2.5 ft	3.3 ft	6.4 ft	8.6 ft	14.5 ft
f/22	0.9 ft	2.3 ft	4.5 ft	6 ft	9.5 ft

Tip #3: Add People to Add Perspective

Sometimes those grand landscape vistas you photograph are simply too grand for viewers to understand. One common reason is that they may lack some type of perspective of size or distance; this is particularly true if the scene is an unfamiliar one.

BELOW: When shooting unusual subjects, adding something familiar, such as people, will give your photograph an immediate size perspective. Put them close to your center of interest for the strongest effect.

Although outdoor and nature photographers normally try to keep people out of their photos, including one or more persons in your image is one of the easiest ways to create a sense of scale and size in a scene. To show the height of a cliff face, for example, try including a hiker or climber at the base of that cliff; instantly your viewer can mentally compare the height of the hiker to the height of the cliff.

Although including people to create perspective in your image is easy, it certainly is not the only way to create a sense of scale. A single tree or a game animal like an elk, deer, or bison can achieve the same effect. What is important is including something familiar and of known size so viewers can more easily relate to your unfamiliar scene.

Composition becomes important when you need to add perspective like this. Certainly, you'll want your hiker or climber near the base of the cliff when you're showing the height of that cliff, but if you're including a single tree in a huge, wide meadow, consider the rule of thirds if you want to show the vastness of the meadow both in front of and behind the tree.

Always remember the center of interest for your image. It will still be the cliff itself or the meadow, not the person you're including. All you're doing by including them is providing a sense of scale so your image is easier to understand.

Tip #4: Shooting Waterfalls and Moving Water

Waterfalls and moving water are often depicted in photographs in which the water itself has no detail; it looks smooth, almost like cotton, while trees, rocks, and other objects are sharp and in focus. Overall, these tend to be very pleasing images, and they're not difficult to take.

To turn water into a soft blur, you need two things, a slow shutter speed on your camera, and a tripod. There is no standard shutter speed because not all water flows at the same rate of speed, so shoot at different shutter speeds. Begin at 1/2 second, decrease to 3/4 and then to a full second. If you still are not achieving the effect you want, continue slowing your shutter speed; you may need two seconds or longer.

One easy way to do this is by setting your camera to shutter priority, which, as you change shutter speeds, will automatically change your aperture setting. Even this may not achieve the overall exposure you desire, so start increasing

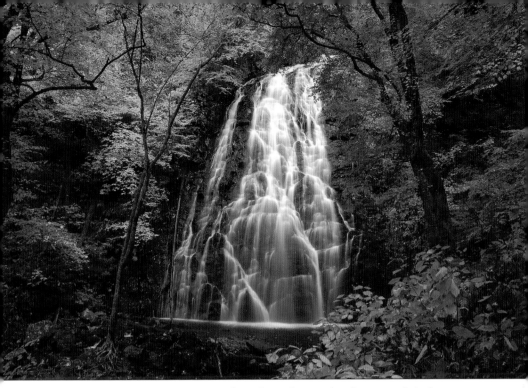

ABOVE: To make moving water appear silky and smooth, use a slow shutter speed of at least one second and usually longer; shoot different exposures to get the effect you want. Shooting early and late helps reduce the contrast.

or decreasing the exposure by using your camera's exposure compensation adjustment, or "magic button."

Using a very slow shutter speed may still cause overexposure even with a small f/stop, especially in brightly lit open scenes, so use a polarizing filter that will eliminate glare and increase the available light by up to two stops. If it is a large waterfall with a lot of moving water, the exposure difference between the water and surrounding trees or rocks may be difficult to manage, so shoot early or late when the contrast will not be as great.

Many waterfall and moving water photographs show great detail in foreground items like rocks, leaves, and even moss. This comes from using an aperture setting of f/16 or f/22; your depth of field with the small aperture opening will keep items in the background in focus. Don't try to focus on the water itself.

Tip #5: Photographing Sky and Clouds

Including some of the sky, and especially a sky with clouds, can completely change the mood of your photograph. Dark gray and even black clouds can impart a feeling

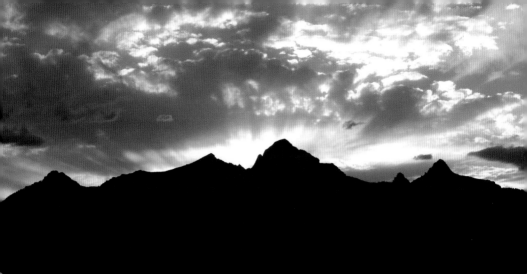

ABOVE: Including dark clouds in your photograph can add drama, while white, puffy clouds can impart a feeling of happiness and well-being. Having some clouds in the sky is often better than a clear sky.

of danger, mystery, or foreboding, while white, puffy clouds can show feelings of happiness and security. Early morning or late evening images in which the sun changes the clouds to yellow and orange can add a mystical, or religious tone to your photos.

When you compose with your horizon line low in your photograph, you generally increase the amount of sky in your image. Gray, featureless skies are seldom desirable in any photographs, nor do you want a sky totally filled with white, puffy cumulus clouds; do your best to include patches of contrasting blue sky around the clouds. Using a polarizing filter will darken the sky and at the same time brighten the clouds for better color saturation and contrast.

Darker skies often indicate an approaching storm. Again, consider mixing any open sky with the clouds, especially of the clouds have a distinct edge to them that indicates an entire frontal system. Exposure can become a problem because the decreased sunlight eliminates detail in foreground objects so bracket your exposures by changing either your shutter speed or your aperture.

Fog can be considered a type of cloud cover, and because it can act like a filter, it may actually increase color saturation in your image. Fog usually forms in the evening and may be present several hours into the following morning; at daybreak it may have a yellowish-gold hue.

Tip #6: Isolate Flowers for More Impact

Ask any landscape photographer his hardest subject to photograph successfully, and many will answer that flowers present their greatest challenge. The problem is

When you photograph a field of wildflowers, such as these bluebonnets and Indian paintbrushes, concentrating and isolating just a few of them may tell a stronger story for you. A low shooting angle can also help emphasize their beauty.

deciding how to define a flower—by its color, by the beauty of its abundance, by its uniqueness, or any of dozens of other ways.

One solution is to isolate either a single flower or small clump of them. Don't worry about showing acres of Texas bluebonnets and Indian paintbrushes, for example, but rather, work with a select few. The reason for starting your flower photography this way is that while it is a relatively easy technique, it will still force you to study the interchange of light and color and composition.

To truly isolate your subject, you will almost always need to position your camera on the same level, or even below, the flower itself. Shooting slightly upward so your background is nothing but blue sky will eliminate unwanted clutter as well as serve to further emphasize the blooms and color.

Using a short to medium telephoto lens rather than a wide angle—anything between 70 and 120mm works well—will also help isolate your flowers. This type of lens has a narrower field of view as well as a shorter depth of field; essentially, you're isolating your subject by focus, in that everything around your flower will be out of focus. You can also isolate your flower by color, such as focusing on a single red Indian paintbrush growing within a clump of bluebonnets, as they frequently do.

Before you press the shutter, look closely to see if there is unwanted material around your flowers, too. Gently remove any weeds or grass stems that may detract from your image, and make certain the flowers themselves are clean and healthy without any insect-eaten petals.

Bright light quickly washes out bright colors, since many flower petals are so thin. Early morning, or a day with light, filtered cloud cover, produce the best color saturation for frontal and side lighting shots. Use a polarizing filter to reduce glare and darken the sky.

Tip #7: Photographing Fall Foliage

Autumn ranks as a favorite filming season for photographers everywhere because of the opportunity to film the brilliant colors of fall foliage. There are many challenges to filming the reds, yellows, and oranges of the maples, oaks, hickories, and aspens, however, not the least of which is simply being overwhelmed by the choices of what to photograph.

Although colorful hillsides and ridges can be spectacular, adding depth by composing with a colorful but well-lit tree or bush in the foreground will make

BELOW: Filming fall foliage can be challenging, so look for different colors to emphasize, possibly including different colors in the background. In this image, there is no question it is autumn and the leaves are changing colors.

your image much stronger. Another technique is to change your wide angle lens to a short or medium telephoto lens, such as a 70-200mm, and concentrating on a smaller portion of the larger scene. Locate a colorful section of trees, then isolate and focus sharply on only a small cluster of leaves. This will produce a blurry but colorful background that emphasizes the story of fall foliage even more.

Isolating brilliant red and orange leaves against a bright blue sky will yield gorgeous images when a polarizing filter is used, but conversely, slightly overcast skies can produce better results than bright skies. The light is much softer, contrast and shadows are not as harsh, and overall color saturation will be stronger. When you do shoot under these conditions, do your best to eliminate this type of featureless sky from your composition.

Early morning light will be another good time to shoot. Look for dew or even raindrops on the leaves. With a heavy overcast, or if you're shooting in shade, adjust your camera's white balance setting to shade or cloudy to help produce more accurate colors. A polarizing filter will also enhance color saturation and reduce glare, even on shiny leaves, and an 81A warming filter will also help eliminate much of the cooler bluish hue that shade produces.

The window of opportunity to film fall foliage is short, normally portions of September and October, and weather conditions may shorten peak color photo time even more. Always check with different sources to get an update on conditions, but be prepared to make more than one trip afield to get the conditions you're looking for.

Tip #8: Add a Starburst to Your Images

Starbursts, also sometimes known as sunstars, are those dramatic photos that include the sun, not as a round ball but as a bright light with rays shooting out of it. Special filters, named cross screen filters, that produce this effect are available from different manufacturers, but you can create the same type of starburst by following several very easy techniques as you shoot.

First, you'll create the best starburst if you use a wide-angle lens, the wider the better; a 17mm lens will create a better starburst than a 35mm lens, and certainly a far better starburst than a telephoto lens.

Second, set your aperture at f/22 or an even smaller aperture if your camera will stop down further. The reason for this is because as the light passes through

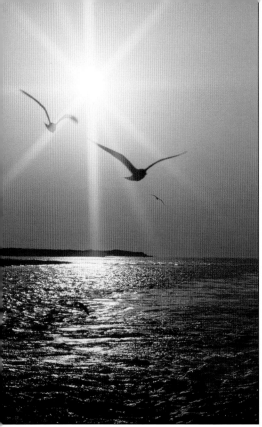

Starbursts are fun to play with and often strengthen an image. You can use special filters or create them by shooting at f/22 and partially blocking the sun behind a foreground object.

this small opening, some light actually diffracts as it hits the hard edges of the lens opening. That's what breaks it up into the rays and creates the starburst.

This is also why wide-angle lenses produce better starbursts than telephoto lenses; an f/22 aperture opening on a wide angle lens is much smaller than an f/22 opening on 200mm lens, which in turn is smaller than f/22 on a 400mm lens, even though they're actually letting in the same amount of light.

You can also create a starburst by blocking a portion of the sun with something in your image, such as a tree, a rock, a plant, or even a person. Using the horizon itself as a block in early morning or late afternoon also works well, and can produce truly dramatic images. Make sure you bracket your exposures by changing shutter speeds, not apertures, as shooting into the sun like this will usually fool your camera's light meter.

Starbursts often produce an unattractive flare that shows up on your image, so look for these before you press the shutter. Blocking part of the sun often eliminates these flares, and other times you can eliminate them or at least minimize them by changing the position of the sun in your composition.

Tip #9: Go Vertical

Even though the generally accepted and most common way to shoot a landscape photo is in a horizontal format, there is no rule to stop you from shooting vertically. It's something you should train yourself to do, regardless of what type of outdoor photography you're doing.

Granted, not all scenes lend themselves to a strong vertical composition, but some that do include generally vertical subjects like tall trees, deep canyons, and steep cliffs shot from a relatively close distance. If you're taking an animal portrait, composing vertically with head, shoulders, and the front legs may turn out to be your best option.

Typically, vertical landscape compositions need a strong foreground to be effective, so look for a potential secondary point of interest to place at the bottom of your image. Something with color, such as flowers, is always a good choice when available. If you want to emphasize clouds or perhaps the sun, a foreground object may not be needed, or even feasible, if you place the horizon low in your composition.

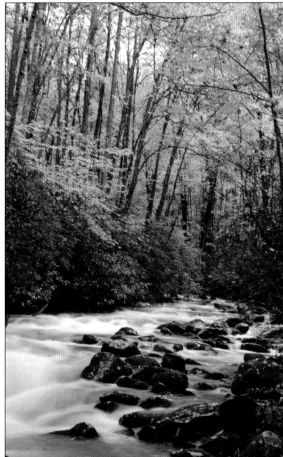

RIGHT: Don't forget to shoot vertical shots with the more natural horizontal format shots. When much of the subject matter in your photo is vertical, such as these autumn trees, a vertical composition will usually be stronger.

Vertical compositions can be extremely effective in showing depth in your image, but not necessarily from the same spot where you just shot a horizontal. Move around if you can and keep looking through your viewfinder. If you're shooting a stream, for instance, getting closer to the shore so you can look more directly upstream or down—you might have to balance yourself on rocks to do this—may give you the perspective you need.

If you ever watch fulltime photographers at work, you'll quickly notice how they continually turn their cameras vertically to check for a vertical composition. It's a habit worth learning because vertical photos can give you a completely different perspective.

Tip #10: Shoot Part of the Picture

One way to shoot a landscape photo is by shooting only part of the picture. That is, choosing a smaller portion of the overall scene in front of you to tell your story photographically. You can convey the same message, but a tighter image may be far more dramatic.

BELOW: You can totally change the perspective of an image by using a different lens and concentrating on just a part of the scene before you, such as with this 500mm telephoto lens shot of a mountain storm. Here the clouds look far more menacing than when shot with a wide-angle lens.

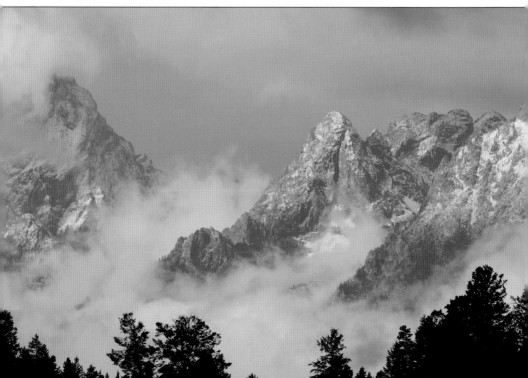

You can do this easily with several different lenses. One way is by changing to a much longer telephoto lens. Wide-angle lenses are most often used in landscape photography because they cover a broader area, and a big telephoto lens focused on the same center of interest will change the perspective completely. If you have a lens in the 300mm to 500mm class, you'll get far more detail in a distant subject than with a wide angle. This is an instance in which you want to eliminate a lot of foreground and background, so don't try to include it.

Even if you only have a medium telephoto, such as a 70-200mm lens, you can do much the same by zooming to the 200mm range and again concentrating on your primary center of interest. The advantage of any telephoto zoom lens is that you can stand in one spot and zoom the lens completely out to its maximum magnification and see what it does for your perspective.

Without a telephoto lens, try shooting part of a landscape scene simply by focusing on something very close and forgetting about the rest of the scene. In a meadow of flowers, for example, or a mountainside brilliant in fall color, it is always tempting to shoot the widest view possible to capture the flowers growing completely across the field or the entire mountainside. While such views can be spectacular, often it is the tighter shot of a handful of flowers, or perhaps even a single red maple leaf, that tells a stronger story.

Tip #11: Getting Close

Getting extremely close to your subject where details become more important than the larger scene itself is a popular form of outdoor photography, and is most often used when trying to capture images of insects and flowers. If you want to get close to a subject like this, you'll be able to focus closer with a short focal length lens, rather than a telephoto.

Special lenses, known as "macro lenses" are also available that are capable of focusing extremely close, and they are sold in focal lengths ranging from about 50mm up to 200mm. If you don't want to purchase one of these, you can opt for a much less expensive close-up filter. These are just magnification filters that screw into the front of your lens, and they're offered in strengths ranging from 1 to 4, with 4 being the strongest. Kits of three of these filters are available at photo supply stores for less than $50.

Depth of field in close-up photography is very short and decreases as you push your camera closer to your subject. Smaller f/stops, such as f/16 and f/22, will increase depth of field slightly, but must be compensated for with a slower shutter

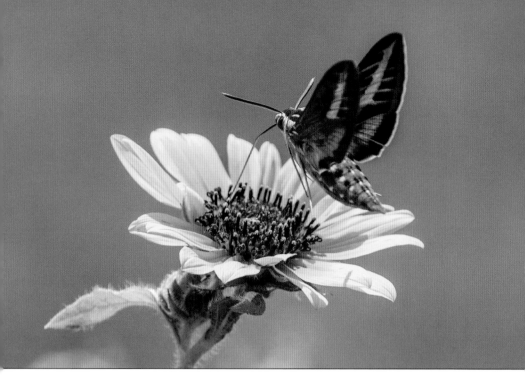

ABOVE: Shooting close-up photos is an enjoyable part of landscape photography, and can be done with a variety of different lenses. This hummingbird moth (*Hyles lineata*) was photographed with a 70-200mm telephoto lens at 1/2000 of a second shutter speed.

speed or higher ISO setting. Even so, depth of field will still be very limited so the majority of close-up work is done using a tripod.

Focusing is critical, so change your auto focus setting to manual for more control; because depth of field is so limited, you want to be able to choose which small part of your image is in focus. This is truly where some compact point-and-shoot cameras do have an advantage, in which you can set the lens for "close-up" and may get everything from four inches to infinity in focus.

Tip #12: Chasing Rainbows

Rainbows are some of the most delightful natural occurrences to photograph, but most appear quite suddenly and then fade quickly, so therein lies part of the challenge of photographing them. A second challenge is making them part of a dramatic landscape image.

Rainbows are created when the sun shines on water droplets in the atmosphere, so in a sense, their appearance is almost predictable. If it is raining in the distance and the sun is shining behind you, or if the sun breaks out through the cloud cover, a rainbow is likely. It will always be opposite the sun, not close to it, in order for the reflection to occur, and it can happen at any time of day. A double rainbow forms

when the sunlight is reflected (it's more accurately described as a refraction) a second time in the same water droplet.

Using a polarizing lens will enhance the colors in your image, but you need to experiment with different amounts of polarization by slowly rotating the filter as you look through your viewfinder. With full polarization, you can actually eliminate the rainbow from your image. Dark backgrounds, especially a wall of storm clouds, will also help highlight the colors in a rainbow.

When you're composing your photograph, you can use either a wide-angle or a telephoto lens, but with either lens your composition will be stronger if you keep the overall scene uncluttered, and also include one end of the rainbow where it touches the ground. With a wide-angle lens, you may even get both ends, with the rest of the rainbow arching across the upper portion of your image. If you choose this type of composition, include flowers, rocks, or even a pool of water in the foreground to add depth and interest. With a telephoto lens, consider changing positions so the end of the rainbow touches down on a grove of trees or some other feature.

Shoot at different exposures and check your viewfinder after each shot, since slightly underexposing may richen your color saturation even more. Using a tripod

BELOW: Rainbows often appear suddenly and disappear just as quickly, so look for them to appear when the sun breaks through the clouds during a rain shower. Use a polarizing filter to bring out the rainbow's colors, and try to include at least one end of the rainbow in your image.

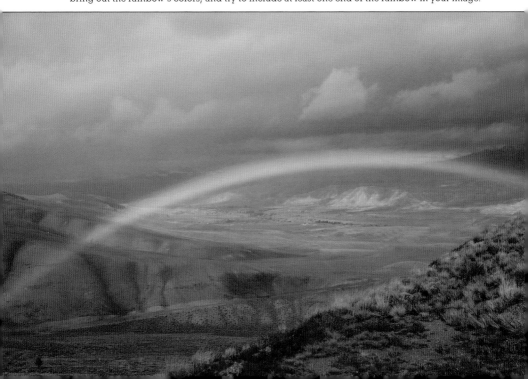

will help insure clearer, sharper images, too, especially when the light is low or you're using a very slow shutter speed.

Tip #13: Watch Out For Lens Flare

A serious gremlin known as lens flare can be a problem in a lot of landscape photography, especially when wide-angle lenses are used. Although today's lenses are far better than those of just a few years ago, some of the light that enters your lens gets sidetracked along its path to the image sensor and creates a line of hexagonal images—the shape of the aperture opening—on your photo.

Even one small flare like this is enough to ruin your picture, so it is far better to keep them out when you're composing your shot than to try to cover them in your computer processing later. The easiest way is to try to keep direct sunlight from striking the front of your lens. You may need to change your shooting position or the angle from which you're shooting, but because lens flare will usually show up in your viewfinder, you will know when you have eliminated it.

You'll also keep a lot of flare from occurring if you have a hood attached to the lens while you're shooting. This is the primary purpose of lens hoods, not simply

BELOW: Lens flare, frequently a problem with wide-angle landscape images, is caused by too much light entering the lens, often from one side. Shield your lens with a lens hood, and use a hat or some other object to also help block the light.

to protect the front element, as many seem to think. Hoods come in different sizes, so use the one designed for your particular lens.

Using a hood may not always be enough, however, so you can also create extra shade by holding a hat, a magazine, piece of cardboard, or even your hand, in front of and to one side of the lens to keep sunlight from entering. This is most often needed when you're working with very strong side lighting. Just make certain not to include your shading object in the picture itself.

8

Fun with Remote Cameras

FOR DECADES, scientists, biologists, teachers, and other researchers have used different types of remote camera arrangements to monitor wildlife populations and conduct animal behavioral studies. From Belize to Burma, Australia to Tanzania, remote cameras have been used to study everything from tigers to butterflies. These remote camera setups, in which the animals themselves take their own portraits, are known as camera traps. They are simply set in place, then checked every few days.

Today, many different manufacturers produce remote cameras for casual photographers. They are more often known as game cameras or trail cameras, since hunters, especially, use them to determine the most productive areas for deer and other game. Trail cameras are fairly inexpensive, fun to use, and can broaden anyone's understanding of wildlife behavior and outdoor photography. They're available in large sporting goods stores as well as on the Internet.

Trail cameras are generally powered by AA batteries (or larger), and utilize either infrared or heat sensors to detect animal movement that activates the

camera. Standard SD (secure digital) memory cards record and store images for downloading into your computer. Image quality is fair to good, depending on the cameras, which have sensors ranging from four to about ten megapixels in resolution.

Personal Interlude

Living as I did for a number of years in Wyoming's upper Wind River Valley on the edge of the Shoshone National Forest, I certainly had ample opportunities to observe and photograph wildlife. Deer and elk were common daytime visitors on the ridge by my home, and while horseback riding and backpacking in the forested mountains nearby I saw plenty of evidence of grizzly bears, mountain lions, and wolves.

Early one January morning after a light snow had powdered the ground, I found a clear, fresh trail of mountain lion tracks leading beside my house, and, thinking the animal might return in a few days, I set up a remote camera to cover the same path of the animal's tracks, as well as the surrounding hillside.

The snow melted and the next morning I actually watched through a window as the camera took pictures of ravens landing in the yard looking for morsels of food. I could hardly wait to download any images from the previous night; that is the excitement of using a remote trail camera. So much wildlife activity we never see takes place after dark, but a remove camera will capture images of anything that walks through its field of detection. When I downloaded my photos, I discovered several deer had come in to nibble on the vegetation, but nothing else.

Because I was leaving town for a few days, I decided to move the camera up into the forest where I could leave it until I returned. At that altitude, nearly 9,000 feet, the snow still lay deep, and practically everywhere I went I found tracks and trails made by both deer and elk. The animals were moving constantly in their search for food.

I found an area where several trails appeared to intersect and the snow had not drifted quite as deep. I strapped the camera to a Ponderosa pine that offered a good field of view out to about thirty feet and pretty well covered two of the trails. If the animals approached from higher up the mountain on their way to the meadow below, the camera should catch them.

Four days later I returned to retrieve the camera, my heart pounding as much from anticipation as from the exertion of climbing through the snow. It had snowed again during my absence and, overall, the weather had been deeply overcast. In the forest, the light had been even more dim and gloomy, so I could not even begin to

ABOVE: Trail cameras are fun to use and help you pinpoint wildlife activity areas, since they are triggered by animal movement. They are used for wildlife research in countries all over the world.

guess how the camera might have recorded anything. Hopefully, there had been some daylight activity so I would have some color images.

There had been. No elk had come down any of the trails, but a small group of mule deer had, and one doe had stopped to nibble on a pine bough one morning. She was even looking at the camera when the shutter clicked. A mountain lion photo could hardly have made me more excited.

Tip #1: Choosing a Trail Camera

Due to their increasing popularity in recent years, trail cameras have continued to improve in quality, with an ever-growing range of capabilities. Fortunately, prices have not increased dramatically, and excellent units can still be purchased for less than $200.

Your first consideration should be the camera's ability to shoot night photos, since so much wildlife activity takes place after dark. Trail cameras utilize infrared sensors, incandescent flash, or white LED flash mechanisms to illuminate a subject. Incandescent and white LED flashes can produce night images in color, but frequently spook the very animals you want to film. Infrared is more widely used in trail cameras, is not as likely to frighten wildlife, and records color during

daylight but only black-and-white photos at night.

Make certain your trail camera has the ability to take several images in succession, a term described as "burst mode." You'll want the highest number possible, which is around ten images, to record an animal walking through your camera's field of view.

Trail cameras record images on a normal SD memory card. Choose a camera that accepts a card of at least 16 GB, and 32 GB if possible. This will allow you to record more images of higher resolution, as well as a longer video, if you choose to shoot in that mode. Resolution ranges up to about 10 megapixels, and you can usually set the resolution quality you want, which should be as high as possible.

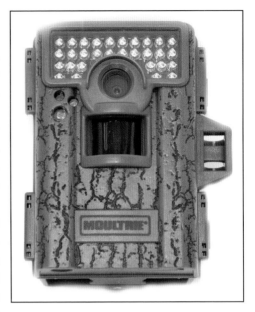

ABOVE: Many different models of trail cameras are available, and they are improving in quality each year as demand for them increases. The most popular trail cameras use infrared sensors to film wildlife at night, although the images are only in black and white.

Wildlife is detected by body heat and movement, with detection zones consisting of a gradually widening, cone-shaped field of view, out to a distance of forty to fifty feet. It takes the camera a certain amount of time, or "trigger speed," to react and take a picture; this should be under two seconds. "Recovery time," the length of time it takes the camera to store the photo on the SD card and be ready for the next shot, should be six seconds or less.

Battery life is dependent on how you set up your camera. You can choose rechargeable batteries if you plan to use your trail camera on a daily basis, or lithium batteries if you use it less frequently.

Tip #2: Test First

Although all remote cameras are designed to do the same thing, each has its own menu of set-up options that allow you to fine-tune the camera to your own requirements. Many of the factory-set adjustments, known as default settings, will not be the same adjustments you want to use; that's why it is important to test the camera

and make certain you have the correct settings before you spend a lot of time putting it in place.

More than anything, you need to become familiar with the detection field and understand how to aim the camera. The detection field changes as you tilt the camera up or down; knowing how close the detection field starts can determine whether or not you get a picture.

Simply walking in front of the camera to activate the motion detectors is not always enough, because if the camera is tilted slightly up, it may only detect your head as the lower portion of the target area. You may need to leave the field, then crawl back into it on hands and knees to see if you still set off the detection lights. You also need to know how wide the detection field is at a certain distance from the camera, so continue moving away from the camera as well as further to one side to learn how the motion detectors are operating.

Other settings your camera may have that you want to change can include multiple shots, in which the camera will take several photographs before stopping to load the images to the memory card; continuous activation or time-lapse operation, in which the camera is only active for a certain period of time; even the length of video it will take, if you're shooting video rather than stills.

You can make many of these adjustments while test shooting in your backyard, with birds or squirrels as your subjects. That way, you can connect the camera to your computer immediately to learn if you need to make additional changes.

BELOW: Always test your camera to make certain you have all the settings adjusted properly before spending a lot of time placing the camera in a remote location. This young mule deer was photographed in the author's backyard one night.

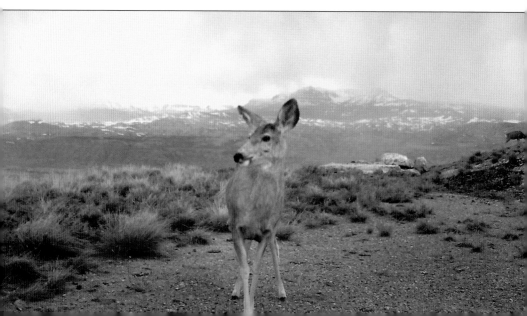

Tip #3: Location, Location, Location

The first time you set up your remote camera, remember the famous axiom used by real-estate agents worldwide: "Location, location, location." You won't get wildlife photos if you don't choose a location frequented by wildlife.

This can be a trail through the woods, an access road into the forest, the edges of streams, fields, and meadows, even in your backyard. Your success will depend on finding some evidence wildlife is using a specific area, which most often will be visual confirmation of the animals themselves, tracks, or droppings.

If you plan to target a specific species, learn as much as you can about the feeding and movement habits of that animal in order to know where to place your camera. Deer and elk, for example, frequently feed in the same meadows day after day, and use the same approach trails to reach them.

Because most trail cameras have a widening cone of detection and can detect movement as much as fifty feet away, consider placing your camera several feet away from the trail. It will still detect movement but will not be quite so obvious to wildlife or to other people who may also be using the area.

Most trail camera users attach their cameras to tree trunks or posts, and the cameras are equipped with straps for this purpose. Other options include

BELOW: One of the most important aspects of successful trail camera photography is placing the camera in an area used by wildlife. Scout the area for signs of activity, such as trails and tracks.

placement around rocks or even on the trunk of a fallen tree, depending on what is available. If you're targeting a small creature like a fox, consider a camera height of around four feet or possibly lower, but if you're after larger game like deer or elk, position your camera higher. The higher you place the camera, the more you will need to angle it downward so it detects animals at close range. Clear away any limbs, branches, or other obstructions in front of the lens.

Don't place your camera facing east or west, because it will be shooting into the sun in the morning or in the evening, the very times wildlife is most active. Instead, point the lens north so it will not have any glare but can still cover your target area.

Tip #4: When to Check Your Camera

The anticipation and excitement of waiting to learn if your remote camera captured any wildlife images can actually cause you to miss some of the best photo opportunities of the day, simply because you checked the camera at the wrong time.

BELOW: Don't check your camera at the prime times of early morning and late afternoon when wildlife may be around, as your presence could move them out of the area. The mid-day hours are often the best time to check your camera.

The basic rule is, don't go into the woods to retrieve your camera in the early morning or late afternoon hours, because these are the times wildlife is most active. Your presence may alarm any wildlife in the area and cause it to leave. Instead, plan to retrieve your camera around mid-day when the chances of spooking animals are much less.

Even then, approach your camera trap slowly and quietly, just in case something may be in the area. The more noise and commotion you make may cause some species to change their approach habits, or even abandon the area entirely.

Once you put your camera in place, resist the temptation to return the very next day to retrieve it. Unless you're focusing on a well-used feeding area, it may take wild game two or three days to return, and you want to make certain you give them that opportunity. Some experienced camera trap users wait a full week before returning. Your batteries will last that long, and each extra day you leave the area undisturbed increases your chances of capturing something really special.

When you do retrieve your camera and have captured images, check the time the photos were taken (you can program your camera to record this information), so you'll have a better understanding when wildlife is in your target area.

Tip #5: Attracting Wildlife to Your Camera

In some instances, you may decide to try to attract wildlife to your camera, rather than just hoping something walks past the lens. Two common methods of attracting wildlife are with food and by calling them with an artificial caller.

Before you do either, however, check your state regulations to make certain it is legal to do so. Some states prohibit using game callers or food at certain times of the year (such as during the hunting season); and if you're in an area inhabited by endangered species, Federal laws prohibit the use of any attractants to draw animals to your camera.

Where using an attractant is legal, you need to know what might be coming to your camera trap, since different foods attract different species. Deer, for example, are easily attracted to shelled corn, apples, and carrots. Foxes, coyotes, or even mountain lions, by contrast, aren't interested in corn, but they'll certainly be attracted to raw meat.

With the exception of shelled corn (available at farm and ranch feed stores), most attractants like this can be purchased at the grocery store. After you have

found a suitable location and put your camera in position, throw or carry your food out into the camera's detection zone. Throwing is better, since it keeps your own scent in front of the camera to a minimum. Don't put everything into a single pile, but rather, scatter it across a broad area so any animal coming in will have to spend more time moving to it. Put your bait out when you're initially putting your camera in place.

Calling wild game into gun or camera range is a long-standing tradition, and is used to bring in waterfowl, turkeys, deer, coyotes, bobcats, and other creatures. Both electronic and mouth callers are available, but you'll need to check the legality of electronic callers in your area.

Predators are attracted by calls that imitate another animal, most often a rabbit, in distress. Deer are often brought into surprisingly close range by rattling a set of antlers together, and elk are attracted in the autumn by imitating their bugling challenge.

All are exciting techniques but require careful camouflage techniques and good woodsmanship. Early and late in the day are generally the most productive times. One problem with calling is that animals coming to your calls often circle to approach from downwind and thus may remain out of the camera's detection zone.

9

Using Compact Cameras

COMPACT CAMERAS are a step below the higher priced and generally more sophisticated DSLR models, which has led to their common description as "point and shoot" cameras. Many different models and sizes are available, and as megapixel counts with these cameras continue to climb, they have risen out of the "spontaneous, snapshot" image category, as well. Many professional photographers take one of these cameras with them as a backup they can easily carry in a vest or jacket pocket, and overall, they are the most popular type of digital camera sold.

Their smaller size, of course, is one of the advantages these cameras have over their larger, heavier DSLR cousins. They're also easier to use, for the most part, since they do not have many of the advanced features top of the line DSLR cameras have. Their lenses generally offer greater depth of field and closer focusing ability, but shorter telephoto capability. Live preview is practically a universally standard feature now, and many compact cameras also offer limited video capability. Certainly, compact cameras are less expensive, too.

The same rules for taking good images apply to compact cameras, however. Light and composition are still critical, but because the sensors in compact cameras are smaller, sometimes the rules have to be applied in a slightly different manner.

Personal Interlude

While taking some friends through Grand Teton National Park one autumn, I stopped at a pull-out parking area along the Moose Wilson Road, where I hoped I could show them some moose at Sawmill Ponds. It's a narrow two-lane road, partially unpaved along part of its route, that winds for sixteen miles between park headquarters and the town of Wilson. On numerous previous trips along the road and at the ponds I'd seen moose enjoying the willows and other marsh vegetation.

Several cars were already in the parking lot, including a white and green park ranger's SUV, and about a hundred feet down the walking trail overlooking the marsh I noticed a small crowd of tourists. A big bull was probably in full view down in the pond.

My friends were not photographers and had only a small Canon compact camera with them, and since they'd purchased it just a week earlier especially for

BELOW: Compact cameras, often described as point-and-shoot cameras, are light, quick and easy to use. Most have zoom lenses and adjustable shutter speeds that allow for shooting under a variety of conditions.

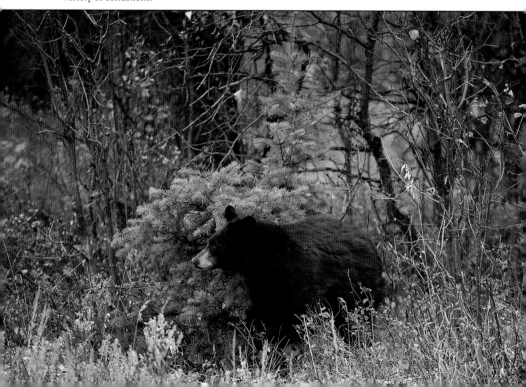

this trip, they weren't completely familiar with how to use it. When we joined the crowd, we saw immediately that they weren't watching a bull moose, but rather, a black bear foraging in the brush not twenty feet away. My friends just handed me their new camera and told me to start shooting.

Fortunately, I was familiar with both the camera and the area the bear was using so I slowly eased to the edge of the crowd to get a better angle of light. I was certain the bear would step into the open in a few minutes, rather than move further back into the forest, and moments later it did. The animal never looked at any of us, but instead, turned and walked away down the same overlook trail we were on. Then it disappeared into thick brush and trees.

My friends, of course, were ecstatic at getting to see a bear, even if it wasn't a grizzly, and I was just as tickled to have gotten some photos for them. I had not even brought my Nikons along, planning instead simply to be their guide. The park ranger had done a good job keeping the crowd quiet and at a distance so the bear was never spooked, and the little compact camera, with its 140mm telephoto lens, and been the perfect tool for the situation.

Tip #1: Choosing a Compact Camera

There are several features to consider when you're purchasing a compact camera. Although the primary attractions of these cameras are their small size and simple point and shoot operation, not all are equal.

Image stabilization—This is what steadies the camera internally when you're hand holding it. It won't correct serious movement, but it does help. Most compact cameras in the mid- and higher priced range include image stabilization.

LCD viewing screen—This is what you use when framing and composing your picture, as well as reviewing the shot after you take it. A 2.5 inch display screen should be the minimum size you consider. A rotating screen will allow you to use more creativity in choosing different angles, and some cameras offer touch-screen ability, but size should be your first consideration.

Zoom lens—A basic consideration is a zoom lens that begins at about 28mm at its widest, and will zoom to between 125 and 140mm. The lens will nearly always be a variable aperture, meaning at its widest (28mm) it will also let in the most light, such as f/2.8, but as you zoom in closer to your subject, the aperture changes to let in less light, such as f/4. Try to get these two numbers as close together as possible, such as f/2.8–f/3.5, but it usually means shorter overall zoom capability and also a higher cost.

Megapixel count—Most compact cameras today have at least 10 to 12 megapixels. The higher the total, the larger the size print you can make.

ABOVE: When shopping for a compact camera, look for features like image stabilization, a large LCD viewing screen, and an image sensor of at least 10 to 12 megapixels so you can make better enlargements.

Sensor size—Instead of counting megapixels, look at the sensor, and you do this by reading professional reviews (available on the Internet), studying how the camera performs in low light conditions. The smaller the physical size of the camera, the smaller the sensor will usually be, which will adversely affect how the camera performs in low light, and not all cameras use the same size.

ISO capability—The ISO should be adjustable to increase the camera's sensitivity to light. Again, study professional reviews to determine how well the camera does this at higher ISO ratings.

Tip #2: Learn the Pre-Set Modes

Compact cameras typically offer a number of different pre-set exposure options when put into program mode that are convenient to use in different photography situations. This is one of the primary attractions that has made these types of cameras so popular. Pre-set modes do produce suitably exposed images, but at the same time they all but eliminate any decisions you have to make in the creative process.

Nonetheless, if you are a compact camera user, it is important to learn as much as you can about these pre-set options. Not all compact cameras offer the same choices, but essentially you will have pre-sets for landscapes, portraits, sports, and possible night shooting. Additionally, you may also have sunshine, cloudy, and other choices for the immediate shooting conditions. Each represents a different shutter speed and aperture opening combination that usually works under those particular conditions.

You need to understand not only the advantages these pre-set modes offer for quick shooting, but also their disadvantages. For example, you already know a fast shutter speed needs a wider aperture, which in turn equates to a shallow depth of

ABOVE: Compact cameras are programmed with several pre-set modes, in which the shutter speed and aperture setting are established. Study these carefully so you can use them effectively under the various conditions.

field. In landscape pre-set, however, you will typically have a very small aperture for greater depth of field, but the shutter speed may be too slow to keep moving wildlife or wind-blown flowers sharp.

Practice with each of these pre-sets so you learn their limitations, and teach yourself how to access them quickly to avoid missing fleeting photo opportunities. Think about using pre-sets in ways they weren't designed for, too; the portrait pre-set is designed with a very shallow depth of field, which might be used to emphasize a sharply focused tree or plant in a meadow with a blurry background.

Tip #3: Understanding Your Flash

Virtually all compact cameras have a built-in flash, but it comes with limitations you need to understand. Its effective range is probably ten feet or less, primarily because it has such a small surface area; and the flash may fire automatically when it detects a low light condition. When it does, the camera usually underexposes your overall photograph, "thinking" the flash will light up your subject.

Your camera should have an adjustment to turn off the flash entirely, so locate this adjustment and turn off the flash when it isn't really going to help you. It is not going to light up the inside of a building, for example, nor is it going to reach an elk standing in the dark timber a hundred feet away.

A compact camera flash is probably most useful in reducing or eliminating shadows that fall within that ten foot subject distance, particularly those at midday. The only way to adjust the output of a compact camera flash is by selecting one of your camera's pre-set automatic modes, including "fill flash," if it has this one. Doing this will tone down the intensity of the flash at close range.

Another solution to keep from potentially overexposing your subject at close range is to diffuse the light. Hold a piece of tissue paper or your handkerchief over the flash as it fires; some experimentation may be necessary to determine if several pieces of tissue will do the job, or if a white handkerchief is too thick.

A possible third solution is to move back a step or two, recompose by using the camera's telephoto lens, and use the flash without diffusing the light.

Tip #4: Change the ISO

Many of today's compact cameras allow you to change the ISO setting, and if yours does (it will either have a visible setting adjustment or you'll find it in the menu), learn how to make the adjustments. The reason is because changing the ISO setting changes the amount of light needed to take a suitable image.

BELOW: The flash units built into compact cameras are not very strong so take several test shots when you first get the camera to determine your most effective shooting distance. Learn how to turn the flash off, too, so it won't shoot automatically in all low-light conditions.

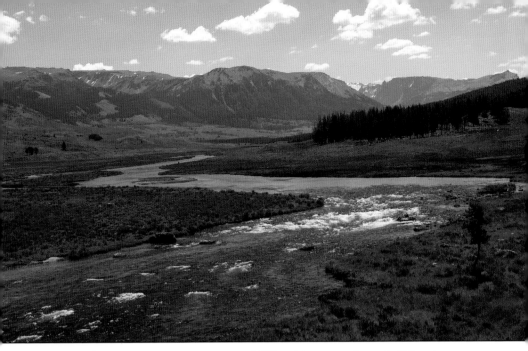

ABOVE: On many compact cameras, just as on DSLR models, you can change the ISO setting. This will allow you to shoot at different f/stops or shutter speeds, depending on the scene you're photographing.

Compact camera flashes rarely illuminate your subject beyond a distance of 10 feet or so, but not using a flash may then require using a long, slow shutter speed to allow enough light to reach the sensor. If you do not have a tripod and are trying to hold your camera steady during this longer shutter speed, you're almost guaranteeing yourself a blurry photo. Increasing the ISO will help solve this problem.

The ISO ratings on compact cameras usually range from around 100 up to about 800, and newer models will go a little higher. For clear, sharp images, an ISO of about 400 should be your upper limit, since increasing the ISO to the camera's upper limits will also cause a deterioration of quality. Each ISO change of 100 measures is just about the equivalent of one f/stop or one shutter speed, so even increasing the ISO from 100 to 400 will provide quite a bit of improvement for low-light photography.

Changing the ISO is one of the major tools photographers use on DSLR cameras to allow shooting in questionable lighting without flash, and it can be a valuable tool with many compact cameras, as well. Compact cameras are often small enough and light enough so you can brace them on any small, flat area to keep them steady during the exposure, too.

Tip #5: Get More from Your Lens

Compact cameras, with only a few exceptions, come equipped with a single fixed zoom lens; interchangeable lenses, common to DSLR cameras, are generally not included

ABOVE: Compact cameras generally come equipped with zoom lenses ranging from about 25mm wide angle to as much as 140mm telephoto capability. Some distortion often occurs at the widest point of view, while the telephoto setting can produce excellent images if the camera is held steady.

in these types of cameras. The zoom lenses typically cover a range from about 30mm to perhaps 140mm, and have a maximum aperture opening of about f/3.5.

Because you do not have lens interchangeability, learn to use the lens you have more creatively. Be especially careful when shooting at the widest angle, because it may distort some images, particularly features of people. Most compact cameras have a pre-set mode for close-up photography, which will provide focusing as close as four inches in some models, and setting the camera on a landscape pre-set mode will provide an extremely deep depth of field.

Moving further away from your subject can alter your perspective because telephoto lenses of all types will compress your image, causing background features to appear closer. Often, this will actually improve your overall image, since shooting wide angle often also includes unwanted or unnecessary clutter.

Just like any other category of cameras, even point and shoot compacts require some knowledge of how to use them more effectively. Learning what the lens does and then practicing more creativity is definitely part of this process.

Tip #6: Focus, Then Compose

On many point and shoot cameras, the focusing sensor is located in the middle of the viewing screen and is not adjustable, which can severely limit your ability to

compose stronger, more imaginative images. A subject in the middle of your photo rarely produces exceptional viewer interest, but fortunately, there is an easy way around this problem with these types of cameras.

When you know what your subject is going to be in your photo, go ahead and focus on it by pressing the shutter, just don't press it all the way down to take the picture. Press the shutter only about halfway down, until you see the autofocus activate and your subject in sharp focus. Then, while still holding the shutter halfway down, move your camera up or down or to one side to create the composition you really want (this is a good time to remember the rule of thirds). When you have that composition, press the shutter the rest of the way.

When you pre-focus this way, you'll also notice that automatic exposure will also be set on your subject, so avoid focusing on a subject that contains either a lot of black or a lot of white coloration, such as shadows or excessive light, as you'll probably end up with an image with large portions that are under- or overexposed.

If this appears to be a problem, there are also easy ways to solve it. First, look for a more neutral "alternate subject" located in the same focusing plane as your main subject, and focus on it. This will lock both exposure and focusing, and, with your shutter still pressed halfway down, allow you to then move your camera to create a suitable composition. If this isn't possible, try moving to a different location in which the overall lighting is more evenly matched.

BELOW: With most compact cameras, the focusing sensor is in the center of the viewfinder, which limits composition choices. By depressing the shutter halfway to focus on the subject, the camera can then be moved so a better composition is achieved.

10

Shooting with iPhones and iPads

IPADS AND iPhones today have become some of the most popular and widely used cameras in the world, and users of these devices have not only recorded history, in some cases their images and videos have changed history. Photographically speaking, iPads and iPhones improve with each new model, too, so there is no denying they are now a permanent part of American culture.

Today's iPads and iPhones come with pre-installed photo apps that allow you to begin shooting immediately. Other easily installed apps, many of them available for free, increase photo capabilities even more; within seconds of recording an image, you can edit and then send your photo around the world. Literally, all you need to do with an iPad is touch the Camera app icon, compose your photo, and tap the shutter button.

Still, with all the advances in electronic technology that have allowed this to happen, the same basic rules of photography still apply if you want to capture compelling images. Light, composition, and subject matter remain of paramount importance, but one of the most important aspects of iPad and iPhone photography

is that everyone carries one or both of these items with them practically everywhere they go today. Because these devices can be "waked up" almost instantly, it means fewer lost opportunities to get just the photo you want.

Personal Interlude

One of the reasons I enjoy traveling and photographing in the American Southwest so much is because I'm intrigued with cactus. There are dozens of different species that grow in the Four Corners area of New Mexico, Arizona, Colorado and Utah, and they come in all shapes and sizes.

They also bloom at completely different times at different altitudes and temperatures, and with different sizes, shapes, and colors of blossoms. That's one part of the challenge I really enjoy, because frequently just a little moisture can make a cactus bloom, and it may not last long.

One summer not far from Albuquerque, I found an area filled with Tree Cholla (*Opuntia imbricata*), a cactus that looks more like a collection of round, narrow stems and which may grow six feet tall and nearly as wide. When I found them, it appeared as if the flowers would open within a day or so.

It didn't happen quite that way. A week later, the flowers appeared no closer to blooming. I walked through the area repeatedly, but all I found were small individual flowers, never an entire cactus with blooms on every stem. Then, light

rain showers fell for two evenings in a row, and the next morning the field was ablaze with burgundy/purple cholla cactus flowers.

I concentrated on one cactus where the stems spread out more horizontally than vertically, and after shooting with my regular Nikon, I switched to my iPad to see how it would capture the gorgeous blossoms. The sky was dark blue with only a few scattered clouds and the light was improving by the minute. I've never been very good at holding an iPad steady while taking pictures, so I braced it on my Nikon, which was mounted firmly on a tripod.

One particular flower had opened at just the right height, and that's the one I focused on. Others behind it showed up as slightly out of focus, but with the foreground flower sharp, there was no question what they were.

The cactus only bloomed for a few days. I walked through again a week later searching for another to photograph, but the flowers were already closed and withering. It was the same throughout the entire area. The desert operates on its own time schedule, and often the door for photography of this type is only open for a very brief interval.

Tip #1: Learn the Camera App

With your iPhone or an iPad, you will shoot the majority of your photos using the Camera app, one of numerous applications that come pre-installed on your unit. Not all devices have the same features, however, which is why your first goal should be learning what the app has, and how to apply them.

Using the Camera app, you can not only take pictures, but also adjust how you're going to take them and then perform some editing after you take them. Just a few of your options include activating the HDR mode, which is especially useful in low-light situations; changing from a landscape (full screen) composition to a square (portraits) format; zooming in for a tighter composition; utilizing selective focusing; adding a special effects filter; turning the flash on or off; and eliminating the red eye effect if you're photographing people at close range.

The Camera app can be opened through the home screen where all the app icons on your phone or tablet are displayed. Simply tapping the icon launches the program. When it opens, the display screen becomes your viewfinder, with some adjustment options shown along the screen edges. Tapping them will put them into effect (pinching the screen activates the zoom features), while tapping them again will turn them off. Sliding the screen vertically will let you switch composition modes, or shoot video.

Keep in mind that exposure is automatic, but you can tell your camera what to expose for and where focus. Tap your preferred exposure/focus spot on the screen

LEFT: Most iPhones and iPads come with a pre-installed photography program named the Camera app. Learning how this program operates should be your first task, because of the different options it offers.

and you'll see a rectangle appear on that spot. This is a valuable tool that gives you more latitude in composition.

To shoot your picture, press the shutter button. If you continue to hold the shutter down, your iPad will continue to make exposures, a nice feature if you're shooting a moving subject. A small thumbnail of your image will appear in one corner of your screen, and tapping on this will blow it up to full screen size. If you want to make some changes in the photo, tap Edit, which opens several options, including cropping, enhancing, adding a filter, and others. Tap the icon for the change you want, or if you don't like what it does, tap Undo to remove it.

When you tap Save, the image is stored in the Camera Roll folder.

Tip #2: Three Quick iPad Tricks

Three features found on most iPads today can quickly change your photos. They are the HDR mode, the zoom feature, and continuous shooting. All are extremely easy to use and worth becoming familiar with if your iPad has them.

HDR stands for high dynamic range, and shows up on your screen above your shutter button as HDR, in small black letters. Although HDR is particularly helpful in low-light situations, you can use it anytime. In HDR mode, your iPad actually takes three photographs instead of one, each at slightly different exposures, and combines the best features of all three into a single image.

It's easy to forget your iPad probably has a zoom feature, but all it takes to activate it is pinching the image on your screen. This will produce a slider bar at the bottom of the screen; just drag the marker dot to the right to zoom in on your subject, or back to the left to zoom out.

Zooming works by enlarging the pixels, so you may notice a decrease in your overall picture quality, but overall, because photography has become such a large part of iPad use, the zoom capability has improved considerably and will undoubtedly improve more in the years ahead.

Continuous shooting is another often overlooked feature of most iPads, but using the burst mode, as it is named, provides the same advantages multiple exposures do with professional DSLR cameras: if you're filming moving subjects or action, you're much more likely to capture the exact shot you want. To activate continuous shooting, simply hold your finger on the shutter button instead of just tapping it as you normally do for a single picture. Not all iPads have a burst mode, but if yours does, be sure to remember it.

Tip #3: Get Close

Because iPads and iPhones do not have high megapixel sensors, they enlarge pixels when you zoom in for a closer composition, so picture quality may not be quite as good as you want it to be. The same thing happens if you do enlarging on the computer. The simple solution is to get closer to your subject, if at all possible, before taking your picture.

This may mean stalking, crawling, or possibly driving, depending on the situation and your subject. An animal's invisible "safe zone" line may determine how close you can approach, but with iPhones and iPads you want your center of interest to be as large as possible on your viewing screen to insure optimum quality. The closer you can get to your subject, the more detail your camera will record.

You will also be able to control image sharpness better when you're close because your subject is easier to isolate with the focusing sensor. Just tap the part of your photo

RIGHT: Three tricks that can improve your iPad photography including turning on the high dynamic range (HDR), pinching the screen to activate the zoom feature, and holding down the shutter for continuous shooting. In HDR, the camera actually shoots three exposures and combines them into one.

you want to make certain is in focus, and on an iPad, the sensor will move to that spot and re-focus. Getting closer will also provide more overall detail in your subject.

Getting close offers still another advantage, which is that you may be able to get a better lighting angle. Again, with fewer megapixels to work with, you want to put as many factors in your favor as possible. In a scene with a lot of contrast or dark shadows, features your iPhone may have trouble handling, getting closer will let you crop out some of these troublespots.

If your iPhone or iPad has a flash, it may fire automatically when you're further from your subject, and do little if any good. Getting closer will allow the light to actually hit your subject. By tapping the lightning bolt icon on your iPhone screen you can gain some control over the flash, such as flashing every shot, letting the camera decide when flash is needed, or turning it off entirely.

Tip #4: Start at the Zoo

Taking photos with iPhones and iPads is a lot different than photographing with a camera, primarily because they don't feel or operate the same way, and they have limitations. For example, for many users, the biggest problem photographing with an iPad is learning how to keep it steady.

ABOVE: One of the best places to learn to shoot with either an iPhone or an iPad is at a zoo, where this image of a rare Mexican wolf was taken. With the wildlife in confined areas, you have plenty of subjects on which to practice different techniques.

That makes starting your outdoor photography in a zoo a good option. You will not only be able to see and photograph different species of wildlife in a variety of habitats and under different lighting conditions. Some will be close to you, others far away, but they won't be able to run away. You can spend as much time with them as your own schedule allows, and you can experiment with your equipment and try different techniques. Many of today's professional wildlife photographers started by filming in zoos and nature parks.

Try to plan your visit early in the morning or late in the afternoon, when animals are most active and also because the ambient lighting will not be as harsh. You may be able to get action photos if you're present during feeding hours; calling ahead will provide you with these times.

Depending on the type of facility, you may have some type of wire fence separating you from the birds and animals. Place your iPad or iPhone right up against the fence and shoot through an opening, if it is allowed. Even if the openings are too small for this, putting your camera against the fence will prevent the wire from showing in your photo. When you can't do this, zoom in for a tighter composition.

Watch the light carefully because you will often encounter very harsh contrasts from one enclosure to another, due to the requirements of different species. Consider activating HDR to help smooth out exposures, use your flash to

lighten darker areas, or compose your images to eliminate as much of the contrast as you can. The main thing to remember is that you're using the zoo as a controlled environment in which to learn how to use your camera.

Tip #5: Shoot Through Glass

When you photograph through a wire fence, you have to get close enough to keep the wire from showing in your picture, and when you shoot through glass windows, such as at aquariums, you also need to get close in order to eliminate flare and reflections. Hold your iPhone or tablet firmly against the glass to keep all stray side lighting from entering your lens. That stray lighting is what causes problems.

Likewise, don't use your flash with either an iPhone or iPad, as it will also create flare. In many situations where you're shooting through glass, available light will be low, so activate HDR to help your exposure. Even with this, however, your shutter speed may be too slow to completely freeze swimming fish. Some species hover motionless, or remain relatively stationary while they're around plants, logs, or rocks, so these may become better subjects for you.

BELOW: When shooting through glass, such as here at the Albuquerque BioPark Aquarium, hold your iPad flat against the glass to keep any additional light from entering the lens and creating a flare. Do not use a flash when shooting this way, either.

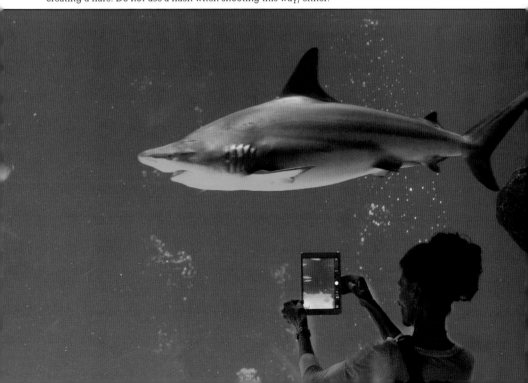

To ensure as much sharpness as possible, don't use the zoom feature. Change positions if you need to and look for a subject closer to you and hold your iPhone or iPhone steady against the glass with a good grip.

Unfortunately, you can't clean the outside of any window you're shooting through, but you can clean your side, and it's important to do so before you start taking pictures. Smudges and dust will show up on your images, so wipe the glass with a small cloth or handkerchief in the spot where you will put your camera.

Tip #6: Brace Yourself

Quite possibly the most difficult aspect of iPad photography is keeping the iPad steady as you compose and press the shutter. By their very design, simply holding them without some natural movement is difficult, and it is compounded by the fact iPads often have a shutter "lag time" between the moment you press the shutter and the moment the picture is actually recorded. During low-light photography, shutter speeds tend be very slow, too.

Holding the base of your iPad on a solid surface, such as a rock, log, or your backpack is a good place to start. Use one hand to hold the iPad and then compose, focus, and press the shutter with your other. If you can, practice what hunters and

BELOW: Holding a flat iPad is a lot different than holding a compact camera or DSLR, so always brace the device on a secure surface, or by holding your arms firmly against your chest.

competition rifle shooters do, which is to breathe normally, let out half a breath, then hold it while you press the shutter.

If you protect your iPad in a small folding case, the case can be used to help steady the camera on these same surfaces. Open it so the cover provides a second edge, like an open book. You'll really see the benefits of this if you do any low-light photography, but it works anywhere, anytime.

You can also brace your iPad against a vertical surface, such as a tree trunk. With your non-shooting hand, push the iPad against the tree and hold it there, further bracing with your elbow against the tree, too, if you need to. Make certain your lens is not blocked by a limb or branch.

If you don't have a surface on which to brace your camera, try bracing both your arms, from shoulders to elbows, against your chest as you hold your camera in front of you. With practice, this can become a habit whether you're using an iPad or an iPhone. Again, take several breaths, then hold it when you shoot.

Tip #7: Shoot Now, Edit Later

For DSLR users, the Trash button is an important tool, but experienced photographers have learned to use it sparingly. They throw away only those images in which

BELOW: When you see a scene you like, shoot photos as long as it exists, and edit your images later. That's because the small screens of either an iPhone and iPad may not give you a clear image. Wait and do your editing on the computer.

their focus or exposure missed the mark by a wide margin. The remaining images are not edited until they're in the computer and can be studied on a large monitor.

The same should be true when you shoot with either an iPad or an iPhone. Save your editing until later when you can see your pictures on a large computer screen. The viewing screens on iPads are just a few inches across, and iPhone viewing screens are even smaller, so your photos will not appear quite as clear or as bright as you want them to look.

Don't throw them away after just a quick, cursory glance, unless you can tell immediately that you need to reshoot. Once you have the images downloaded into your computer, you can really study your photos more carefully, and you probably have more editing options available to use. You'll be surprised at how many "bad" images you can save with Photoshop, Elements, or another image editing program.

Two of the most common problems with iPad and iPhone photos are either a picture that is dark because you shot into the sun, or it's out of focus because you weren't holding your camera steady. You really can't correct these issues in the computer, but you can while you're shooting; change positions so the angle of light is better, and brace the camera before you press the shutter.

Tip #8: Filter It

One feature you'll want to use on either your iPhone or iPad is the availability of filters, which you'll find in the Camera app. On the latest iPhones, you can use one of eight different filters while you're actually shooting, or you can add them later as you're editing. With your iPad, the filters are available when you edit after shooting.

There are eight filters available in the Camera app, ranging from mono, which turns your color image into a black-and-white photo, to chrome, which enhances the colors you originally recorded. On both your iPhone and iPad, you can review the new photo and either save it or revert back to your original image.

To add a filter with your iPad, select and tap an image in your Camera Roll folder. When the photo comes up to fill the screen, tap Edit in the top right corner. When you do this, a panel of five options will appear along the bottom of the screen; tap Filters. This will produce eight thumbnails of your original image, each with one of the eight filters applied. You can tap any of the thumbnails to see an enlarged photo, and then either tap Apply or Revert to Original at the top of the image.

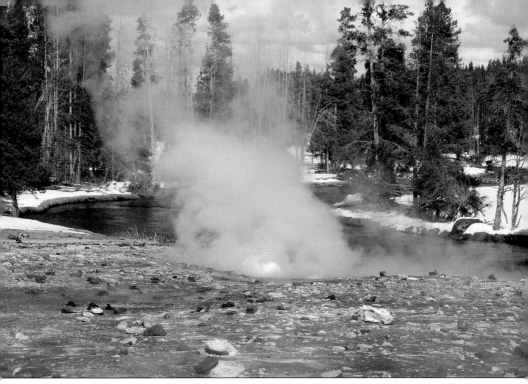

With an iPhone, tap the Filters icon in the bottom right corner of the screen. A selection of nine thumbnails will appear, with the name of the filter. The ninth thumbnail will be labeled None, which means no filtration will be added. Tap one of the thumbnails, and the image you're composing will show up on the screen, with the filtration added. When you press the shutter, your photo will have the filter included.

You can also add filtration later on your iPhone photos, tapping Edit and then the Filters icon, when your image shows up on the screen.

Tip #9: Add More Photo Apps

While the Camera app on your iPad or iPhone provides a good introduction to photography, literally hundreds of additional apps are available that provide many more options in both taking pictures and improving them. Start looking for them in the App Store under the category of Photo & Video on your iPad or iPhone.

Here are some apps that have become extremely popular with photographers, due not only to their ease of use but also because of the corrections they offer:

Hundreds of different photography apps are available to download for both iPhones and iPads that can improve your camera's ability to record the types of images you want. Many post-processing apps are also available; you can find them in the App Store.

Pro HDR—This app costs $1.99 and includes slider adjustments for contrast, brightness, saturation and color. You can add filter effects, including infrared, and crop your photo to the size you want, all within a few seconds.

Camera +—This $4.99 app includes a clarity filter to increase sharpness, a slider to adjust white balance, and controls for brightness, contrast, and saturation. There is also an adjustment for straightening a tilting horizon.

Perfectly Clear—If you've experienced that annoying purple haze in some of your iPhone photos when you photographed in bright light, a single tap on the screen with this $2.99 app will eliminate it. That same tap on the screen will actually make 10 individual corrections to your image, working with every pixel independently.

Adobe Photoshop Touch—For $9.99 you can have an app that does the same thing on your iPad that it does for DSLR owners on their computers, applying professional enhancing techniques for all your photos.

As you become more skilled with your iPhone or iPad tablet, consider adding one or more new apps like these that can change and improve your photography dramatically. You can make the enhancements immediately right on your iPhone or iPad, too, without having to first download your images onto a computer.

11

Traveling with Your Gear

TRAVELING WITH your camera equipment, either to a destination or even once afield at that destination, can bring mixed feelings. There is excitement and anticipation, but both can be tempered by the dread of packing and carrying that equipment. These are natural emotions, and will usually become stronger as your equipment list increases and your destinations get further away.

One general rule is to take only that equipment you know you'll use, but this can be self-defeating for your creativity level. Two other rules may be more realistic for your particular travels, especially if you're flying to your destination: carry as much with you on board as allowed, and pack the rest very securely in hard, lockable cases with ample padding.

There are many different options for packing your gear, so don't hesitate to talk with other photographers and even with airline officials. Regulations are not always the same among different carriers, so study their recommendations. Around the world, hundreds of photographers cover thousands of miles every week without any serious problems, so don't cancel what may be the trip of a

lifetime just because you're hesitant to travel with your equipment. Once you're on location, carrying that equipment as efficiently as possible will make your actual photography work much easier.

Personal Interlude

Years ago, while waiting in the Delhi airport after a photography trip to India and Sri Lanka, I watched with growing alarm as two heavily armed men in starched military uniforms walked into the crowded room and began looking over the passengers. One of them held an easily recognizable sheet of paper—my typed list of the cameras and lenses I had with me that I had left at the counter when I checked in for my flight.

I was probably the only American in the room at that moment so I was easy to spot, and when one of the men saw me, he simply motioned me over with a slight wave of his hand. Without a word he ran his index finger down my equipment list, stopping and tapping the paper at "400 mm telephoto lens."

I had packed this lens in its own case and surrounded it with clothing in my suitcase, and when I described this to the men, they simply motioned me to follow them through a set of swinging doors and out onto the open tarmac. There, a few

BELOW: The author received special permission to use a flash for one photograph of this green sea turtle digging her nest on a deserted beach in Costa Rica. When traveling in foreign countries, special photography restrictions often apply.

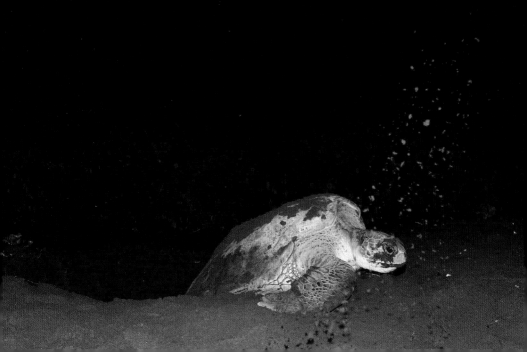

feet from the door, stood a big rolling cart with all the yet-to-be-loaded luggage of our flight.

I pointed out my particular suitcase, and the soldiers immediately began pulling off other cases and bags to reach mine. By now my heart was racing, and I had no idea what was happening. I unlocked my suitcase, dug through the clothing for the lens, and opened the case for them. I carefully slid the big lens out, and handed it to one of them.

To my surprise, he took it gently, held it up as if admiring it, and a broad smile crossed his face as he handed it to his fellow soldier. The second man likewise held it up, and when I removed both the end cap and lens cap, he looked through it as if it were a telescope. He was smiling and nodding, too.

They handed the lens back to me with a nod, and after I repacked it in my suitcase, they piled the other luggage back on top of it and together we walked back through the swinging doors and into the waiting room. Then they bowed slightly, and walked out of the room. They had never said a word, and to this day I am convinced they were amateur photographers themselves and had simply never seen a big telephoto lens.

Tip #1: Pack Securely

Traveling with expensive photography equipment can be a daunting experience, especially if you have to check a camera case at an airline counter, then watch it disappear down the conveyor belt with other suitcases and duffle bags.

One solution is to carry as much on board with you as possible, but if you must check a camera case, use a hard case, not a soft-sided one, and certainly not a common backpack-style camera bag. Several firms make hard cases, and in various sizes to suit your needs; some are now made with extending handles and rollers so they look like ordinary pieces of luggage.

These cases usually come filled with foam, which you then cut out to fit your different camera bodies and lenses. Pack your equipment tightly with plenty of padding; you don't know how the case will actually be handled after it does go down that conveyor belt. Separate all lenses from your camera bodies to avoid potential damage to the mounting threads and pins.

These cases can be locked, so use a TSA-approved lock that airport safety personnel can open without cutting. These cases have the added advantage of also being dust and waterproof; some photographers work out of their smaller cases for those very reasons.

Remove the batteries from your equipment and pack them separately, even in the same hard case and surrounded by padding. If your case is X-rayed, your memory cards will not be affected.

Tripods can be packed in clothing duffle bags. Remove the head and pack it separately; if you need a screwdriver to do this, tape the screwdriver to one tripod leg so you'll have it at your destination. Wrap the tripod heavily in padding, clothing, or towels.

Tip #2: Carrying Your Cameras

Backpacks, or more accurately, photopacks, are among the most popular and efficient ways to carry your cameras and lenses while you're actually shooting. They are made in different sizes and designs to accommodate varying amounts of equipment.

Photopacks are usually heavily padded to protect your equipment, and some are quite heavy, even without your cameras and lenses packed inside. This problem only gets worse if you purchase one of the larger packs and then fill it with more of your gear. Many of the larger packs are designed to carry not only cameras, but a laptop computer, as well.

In many environments, special backpacks, or photopacks, are the best and most efficient ways to carry your equipment, especially when you're in the field shooting. Make certain the one you have is waterproof as well as comfortable to carry.

Photopacks are designed with padded dividers that are attached in place with Velcro. Thus, you can rearrange these interior dividers to suit your specific needs. If you're thinking of using one of these packs to carry a big telephoto, you'll be able to do it, but generally, a medium-sized photopack will carry two camera bodies, three or four lenses (depending on their size), and an assortment of filters, flash units, and a memory card holder. These bags will also have one or two zippered compartments, and possibly extra straps for carrying a tripod.

Many photopacks will fit in the overhead storage compartments so you can fly with them as carry-on luggage. The straps then allow you to wear it like a regular backpack. The best photopacks are made of heavy Cordura and are water-resistant, but you can spray on extra water proofing if you know you're going to be in damp conditions.

The easiest ways to work with a photopack are to either put it on the ground if you're going to be in one spot, or to carry it over one shoulder so you have quick access to it.

Tip #3: Wear a Vest

If you've been to a college or professional football game and seen the photographers along the sidelines, you may have noticed that most, if not all of them, were

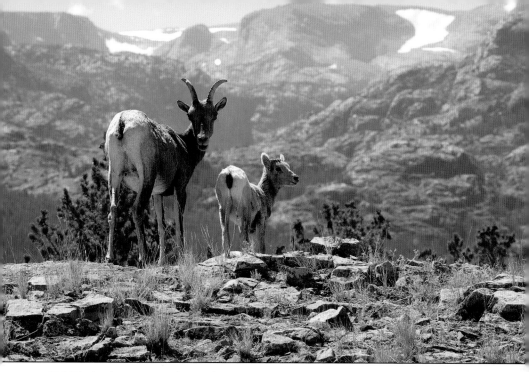

ABOVE: An alternative to a photopack is to wear a special photographer's vest, particularly if you're not taking much equipment. Vests have large pockets that can usually hold an extra lens, memory cards, and even a flash unit.

wearing vests. There's a good reason for this, which is that photographer's vests are the ideal garment for carrying photo items when you're shooting from different locations.

Photo vests are available in different styles, with the most efficient ones reaching to thigh-length and featuring both large and small pockets. Long-sleeve jacket-styles, in which the sleeves zip off, are also available and provide extra protection in cooler weather. All are available at leading photography supply stores, with prices usually starting at around $75.

Vests do not have padded pockets, so while they're excellent for carrying smaller items like filters, memory card wallets, extra batteries, and perhaps even a flash unit, care should be taken when you pack an extra lens or spare camera body. Still, if your shooting location involves a hike, such as to a distant rock formation or waterfall, or, like the football photographers, requires you to move often, a vest gives you much more freedom and manageability than a photopack.

A vest will limit the amount of equipment you can carry with you, so plan carefully about which items to take. A 70-200mm lens will fit in some pockets, as will shorter telephotos and wide-angle lenses. These are basic lens choices, and you will probably attach one to a camera body and walk with it over your shoulder. That will leave plenty of room for other items, even including a water bottle and sunscreen.

A power converter will be needed to recharge camera batteries and possibly run your computer if you travel abroad. Other items to take include extra batteries for your cameras as well as a flash unit. Large plastic garbage bags will help protect a vest or small photopack in wet weather, too.

Tip #4: Remember These Extras

Among the items to include when you're traveling abroad is a power converter unit so you can use your computer and re-charge batteries as necessary. Many foreign countries use a different voltage system that isn't directly compatible with American equipment, so the power converter is extremely important. They're available at better camera and electronics stores, cost between $30 and $50, and can easily be packed with your camera gear.

If you take a laptop computer along to view and process your images, an external hard drive will allow safe storage of literally thousands of photos. They're also small, plug directly into your computer via a USB port, and available in various storage capacities. Using an external hard drive will keep work space free on your computer, too.

You'll also want to pack extra memory cards; several smaller capacity cards, such as 32 GB, are normally better than a single 128 GB card, because memory cards have been known to fail (rare, but it does happen). Smaller capacity cards also download quicker and are easier to organize.

Don't forget to pack at least one spare battery for each camera you take overseas, and extra batteries for your flash unit. Pack these separately—the TSA may require you to have them in a see-through plastic bag—in a carry-on bag or your camera case.

Regardless of whether you're using a hard case or a Cordura photopack, include a small hand towel, and one or two heavy duty, large capacity plastic garbage bags. You can use the towel as extra padding, and fold the garbage bags flat and slip them into one of the zippered compartments for emergency use if you get caught in a sudden downpour.

Tip #5: If You Travel Overseas

Photographers are divided in their feelings about the need to register their photography equipment, laptops, and even iPhones and iPads with US Customs officials before departing the United States. Many who travel abroad frequently have never registered their gear and never had problems, while others have literally had to pay duty fees on their own equipment.

There is no law that requires you to register your gear. The purpose of registration is to prove you owned the items prior to leaving, and did not purchase them overseas at generally reduced prices. The burden of proving this is yours, and the way you do it is with a Customs and Border Protection (CBP) Form 4457.

ABOVE: If you travel overseas, consider filling out a Customs and Border Protection Form 4457, which proves your ownership of your photographic equipment upon your return to the United States so you won't have to pay import duties on it.

You can download this form at www.forms.cbp.gov/pdf/cbp_form_4457.pdf. On it, list your equipment, including name, brand, and serial number. If you will be traveling overseas more than once, list all your photo gear, even if you aren't taking it; if you need additional space, fill out several forms. Form 4457 can be re-used as often as you travel and does not need to be renewed.

Once you have filled out this form, you must personally take it, and all your equipment, to your local customs office, also known as a Port of Entry. You can find the address of the one nearest you at this website: www.cbc.gov/contact/ports. An official will verify the form and your equipment, and then sign the form. Keep this with your equipment or your passport as you travel, and if you are questioned upon re-entry into the United States, simply present it to the customs officials.

Tip #6: Know the Local Customs

If you're heading into a location you haven't visited before, make certain you're familiar with local customs before you start shooting. In some areas, photography is not allowed, or prior permission before filming may be required.

This is true most often in foreign countries, but there are also some Native American cultures that limit photography in specific places. On certain Navajo tribal lands in Arizona and Utah, for example, guides are required for entry into portions of the area and prior permission must be obtained before photographing tribal members. In many African national parks, photography is limited to daylight hours only, since safari travelers are required to be in their lodges or camps by nightfall.

Payment may be required to photograph at certain locations or times, and individuals may expect a token payment when you film them. Learn and remember these customs before you start shooting, and always respect them. If you're unsure of the correct procedures, ask for clarification, especially the proper amount to pay someone who has let you photograph them. Knowing a few words of the local language, such as the words for "thank you," will take you a long way in situations like this.

In some areas, you may attract a local crowd around you while you're shooting. If you see this happening, keep a watchful eye on your equipment and always have it close to you. This is when it pays to only have a single bag of gear you can wear on your shoulder, or a vest.

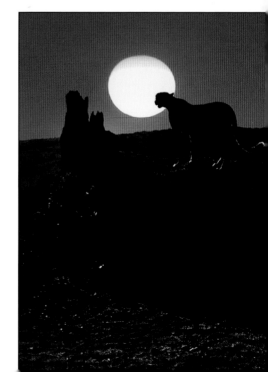

RIGHT: Always know the customs of the country or area into which you're traveling, as special rules governing photography apply. Even in portions of the United States, special permission must be granted in order to take photographs.

(12) Your Digital Darkroom

THE TERM "digital darkroom" refers to the computer and software programs needed to process your images, and the different steps used in that processing. It is also a reference to the long-gone days when photographic film, both color and black and white, had to be processed in a true dark room with trays of chemicals.

There are several image-processing programs commonly used by digital photographers today, including Photoshop, Photoshop Elements, Paint Shop Pro, and others. The important thing to realize about any of these programs is that there is no specific order required to go through the various steps of image processing to reach your final result, and not all photographers even use the same processing steps.

The steps you follow are often determined by the original quality of your image and how you want it to look; what generally evolves, however, is a regular sequence you will tend to follow each time you process one of your images, simply because it works for you. This sequence is known as your workflow.

These different processing steps are performed with what are known as "tools," and in Photoshop, for example, the different tools are arranged along one side of your image in what is commonly described as the "palette." Additional

options, each with its own sub-menu of choices, are located across the top of your computer screen in what is known as the "tool bar." When you begin using an image-processing program, do not try to learn all of these at once, because you won't need or use everything that's available. Experimentation will be your best teacher.

Personal Interlude

In 1999, nearly a full five years before I began shooting a digital camera, I learned of a man in Weatherford, Texas, named Don Lambert, whose company, Airbrush Imaging, could print stunningly beautiful color photos on canvas. Weatherford was only twenty-five miles from where I lived at that time, so I telephoned for an appointment and drove over. I took several 35mm color transparencies with me for possible printing.

Airbrush Imaging, I learned, was run solely by Don and his wife Barbara, and Don had been working with Photoshop since late 1989 when it was still Photoshop 1. I also learned later that he was widely considered one of the best in the United States at post-processing and printing digital images. My initial visit that afternoon lasted several hours, rather than minutes, as Don scanned my transparency of a wood duck, then went to work on it in his computer.

It was my first introduction to Photoshop. There was a small light flare on the picture, and in a heartbeat Don had cloned it away. Then he cropped out some of the foreground vegetation that distracted from the duck itself. He made the water more blue, the bird itself brighter. It looked pretty easy, and I remember making the comment I thought I could learn the program in just a few months. Don laughed. He originally thought he could learn Photoshop over a Thursday-to-Monday Thanksgiving holiday, and now, a decade later, he was still learning it. I'm still learning it, too, fifteen years after our initial meeting.

Don, Barbara, and I became fast friends that afternoon, and he has continued to be my mentor over the decade and a half since that autumn visit. He, more than anyone else I know in photography, has experienced not only the evolution of digital photography, but also the parallel evolution of image processing programs. In the early days, there was no way to print directly from a computer like there is today; instead, he had to copy images to a floppy disk—there weren't any CD's then, either—and then transfer them to film, which had to be done by another company, before he could print them.

On many an afternoon I sat beside Don at his computer, and scribbled notes as he performed some miracle of improvement to one of my images. Then I rushed

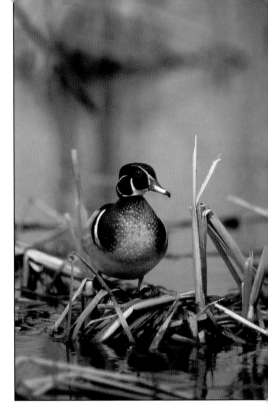

home to try to duplicate it on my machine. That's pretty much how I learned Photoshop, and I still follow his guidelines today. What makes him so good, I realized, it that he is at heart an artist, and he knows how he wants a picture to look. Photoshop gives him that opportunity, and I was very fortunate to meet him and have him share that opportunity with me.

Tip #1: Study and Duplicate First

Before you begin post processing on an image, it's a good idea to first study that image on your computer screen and determine if you really do want to spend the time working with it. Click the zoom tool in the palette and see just how sharp your photo is, and look at the histogram to check the tonal range.

If you decide to work on a photograph, it's a good idea to make a duplicate copy of that image. You can do this by opening the image in Photoshop, then clicking on Image > Duplicate. The reason for doing this is because if your image was originally shot in the JPEG format, each Photoshop change you make is a permanent one and can't be undone, only corrected again.

Keep your original photo files in a separate folder, discarding the obvious bad ones and those you don't want to keep. If you mess up an image in Photoshop or

Elements, you can return to this folder, make another duplicate copy, and begin processing again.

Making a duplicate copy serves another important purpose when you're still learning some of the basic steps in processing. The best way to learn Photoshop or Elements or any of the other image-processing programs is by experimentation. Move the adjustment sliders back and forth just so you see what effect they'll have on your image, and moving them will have an effect.

Because you're working with a duplicate copy of your image, you can do anything with it you want to do, knowing you still have the original that hasn't been changed. Makes some notes when you see an adjustment you do like, then incorporate it when you do your real corrections.

Tip #2: Basic Cropping

For many photographers, the first step in their digital workflow, after an image is opened on the computer, is to crop it to a more agreeable composition or size.

To do this, go to the bottom of the palette to the zoom tool, which looks like a small magnifying glass. Click on it as many times as you like to enlarge your image; this will not only give you an idea of what cropping will look like, but also show you the overall quality of your image. To bring the image back to its original size, click on View in the tool bar, then click on Fit on Screen.

In Photoshop, the cropping tool is the fifth tool down in the palette. It looks like a small square, but with overlapping corners. If you have trouble identifying any tool in the palette, hold your curser on it but don't click your mouse; the name of the tool will appear beside it. When you click on the cropping tool, size options will appear over the top of your image, including width, height, and resolution. Initially, you can leave these blank, or if you know the exact size you want for your finished photo, type in those numbers. For resolution, type in 240 or 300, the common resolutions used in publishing.

Move your cursor to your image, and with your mouse depressed, slide the cursor across the image. The resulting dotted line will outline your crop. You can change the crop by pulling on the corners and sides, and if you hold the cursor inside the cropped area and slide it, you can move the entire cropped area at once. When you move the cursor just outside the top crop line, you'll see a small curved arrow; by sliding your cursor up or down, you can rotate the cropped image slightly to straighten a slanting horizon.

BELOW: Many photographers prefer to make a general crop of their image first, as shown in this image of an antelope leaping over a fence. This might be your final crop, or you may decide to re-crop it later.

When you have the crop you like, go into the tool bar at the top of your screen, click on Image to open the drop-down menu, and click on Crop to show your new photo.

Tip #3: Using Levels

Many photographers begin their digital darkroom process with levels, an important but extremely easy to use tool that adjusts the contrast in your photograph. With levels, you can create a fresh, vibrant image out of a dull, washed-out one by moving sliders to individually change the shadows (blacks) and highlights (whites)—the tonal range—in your photograph. You can also change the overall tonal range, as well.

Open levels in Photoshop by clicking on Image > Adjustments > Levels. When you do, a histogram will appear showing how the tones are distributed in your image as it was taken. Normally, this chart will have one or more mountains rising in the middle, with blacks represented on the left side, and whites on the right. Immediately below the histogram you'll see three small triangles, or sliders; by placing your cursor on any of these and "sliding" it, you'll see how the tones change.

BELOW: Levels allows you to adjust the tonal range of your photograph, as shown on the histogram here. This is often one of the first post-processing steps done by photographers.

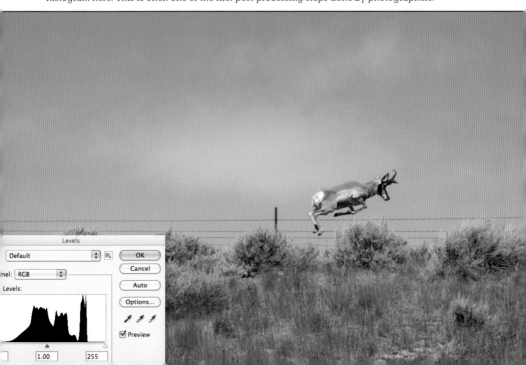

Begin with the left (blacks) slider and move it inward to the left edge of the mountain. This will cause the blacks in your image to become darker, but just as importantly, this will insure you have pure blacks in your photo.

Now, move the right (whites) slider inward to the right edge of the mountain. Be careful here, however, as any underexposed portions of your photo will become even more washed out. Finally, move the middle slider either to the right or left depending on how you want your photo to look. This slider adjusts the mid-tone range and will darken or lighter the overall image. By moving it to the right, you can replace some of the detail you may have removed when you moved the white slider inward.

This is one of the most important early steps in your workflow, and you will be able to see an immediate difference in your image quality. What you've done is insure your photo has a full range of tones, and the more you work in Photoshop, the easier it will be to see these differences. When you have the adjustments the way you like them and your photo looks good to you, click on OK to close levels.

Tip #4: Add a Curve to Your Workflow

While levels is certainly one of the easiest adjustments to change shadows, midtones, and highlights, another tool named Curves allows a more precise adjustment of these tonal areas in your photograph. Some photographers don't include curves in their regular workflow because not all images will need these types of adjustments, but it is worth knowing about because it is so precise.

When you open curves from the toolbar over your photograph, Image > Adjustments > Curves, a box opens with a diagonal line crossing from the lower

BELOW: Curves is somewhat similar to levels, except that it allows for more precise adjustment of the colors in your image. The tonal range is represented by the diagonal line, which you can adjust anywhere along its path. Photo by Valerie Price Seals.

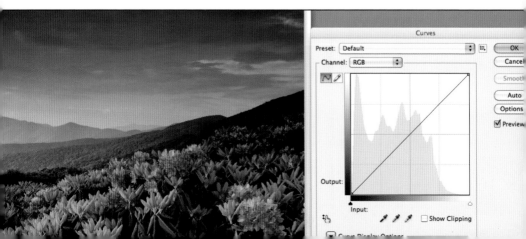

left corner to the upper right of the box. The lower left part of this line represents the darkest pixels, while the upper right represents the brightest pixels. A lighter shadow behind the diagonal shows the highlights and shadows in a graph so you know where they are on the diagonal line.

To change one of these tones, place your cursor anywhere on the diagonal and drag it up to lighten or down to darken. As you do this, the straight diagonal will curve, thus the name of this tool. Each time you click on the diagonal you create what is called a control point, and you can create as many of them along this diagonal as you want, which allows for the precision adjustments that levels does not.

The easiest way to learn curves is by playing with it with a duplicate image. Just pick a spot you want to darken or lighten, and drag the diagonal up or down while watching the tones in your image change.

Tip #5: Saturate the Color

Much of the processing you do to your images in Photoshop or Elements will be to modify or improve the overall color of your photograph. One easy way to do this is using a modification known as hue/saturation. In the Tool bar, click on Image > Adjustments > Hue/Saturation.

Saturation, the richness of the colors, is the most important adjustment you'll see when this box opens. The easiest way to see how this can change your image is by moving the slider all the way to the left to -100. Suddenly your photo has no color at all, only varying shades of gray. Now, move the slider all the way to the right to +100, and instead of grays you'll see psychedelic shades.

BELOW: Hue/saturation is one of the major color adjustment tools available in Photoshop and other programs, and is used to help make colors bolder and more vivid.
Photo by Valerie Price Seals.

Obviously, neither will be satisfactory, so move the slider back to 0, and then gradually move it to the right, perhaps to a setting of 6, 10 or 12. This will be your judgment, as there is no automatic setting that is absolutely correct, but rarely should you need to go above a setting of 20, since too much saturation makes the image look unnatural.

The hue adjustments go from +180 to -180, and can change the overall color of your image dramatically, so again, starting at 0, move the slider in very small increments, as all colors in your image will be adjusted. This adjustment is best used to adjust specific colors, however, so in the inset box, click the small arrow beside Master, then choose green, for example, and then move the slider toward the green. Only green will be changed. You can do the same with blue, to make the sky darker, or change any other specific color without changing the others.

When you're satisfied, click OK to confirm your adjustments.

Tip #6: Cleaning by Cloning

One of your most important tools in Photoshop is named the "clone stamp" you can use it to "remove" unwanted items in your image, ranging from dust spots to trees to automobiles. The clone stamp does not actually remove them, it covers them, or "clones" them by matching the pixels from another spot on your image that you've chosen.

To activate the clone stamp, first click on the icon in the tool box. Then, hold down the Option key (Mac) or Alt key (PC) while you move your cursor to a spot on your image that will match the background once you've removed the unwanted object. When you have your background sample chosen, click to mark it with the cursor. A small + will appear on your screen, while your clone brush appears as a circle.

Now move the cursor (circle) to the area you want to cover, and slide it (if a large area) or just click it repeatedly as you move it through a smaller area. You may need to stop and reposition the clone + marker periodically because it will pick up whatever it touches.

For small, tight cloning areas, use a small brush. You can change the size of the brush (circle) with the brackets on your keyboard (not the parentheses)

Because the clone tool is picking up pixels from the sample area you choose and duplicating them in another area, remember that it will be just that, a duplication of the very same rock, bush, or background. This won't look natural, so blend the background by choosing samples from different spots. With a little practice, you'll easily be able to improve your photos with this tool.

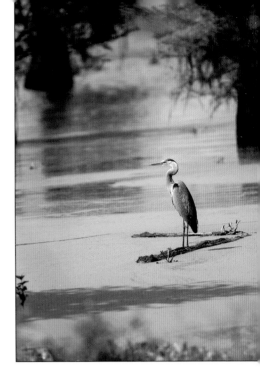

RIGHT: The clone tool, located in the tool palette, does not remove blemishes and unwanted items in a photo, but instead, covers them with pixels "cloned" from another part of your photograph. Here, some distracting weeds and brush in the water has been cloned away from the great blue heron.

Tip #7: Make It Sharp

There are several sharpening techniques available for your images, but "unsharp mask," found in both Photoshop and Elements, is the easiest to use to correct a slightly blurred photo. You can access it in the toolbox by clicking on Filters > Sharpen > Unsharp Mask. Before you do any sharpening to your image, however, make certain you have it cropped to the size you want it to be. If you don't, anytime you change the size of the image, either making it larger or smaller, it will not be as sharp.

The unsharp mask tool works by increasing the contrast between the pixels, which is done with sliders, as you'll see when you open the tool. As in many other post-processing procedures, one of the best ways to learn to use the unsharp mask is by making a duplicate copy of your image (Image > Duplicate) and moving the sliders back and forth to see how they impact your photo.

For a starting point, set the amount to about 150%. This is where most of your sharpening is done, and you can keep increasing the amount, depending on how out of focus your image is. Keep the radius slider to less than 4 pixels; if you increase much more, you'll notice the highlights in your image start to burn out and lose detail. Keep the threshold slider at 0 so the smaller details in the image are sharpened; if you move it further to the right, you will also see some sharpness disappear.

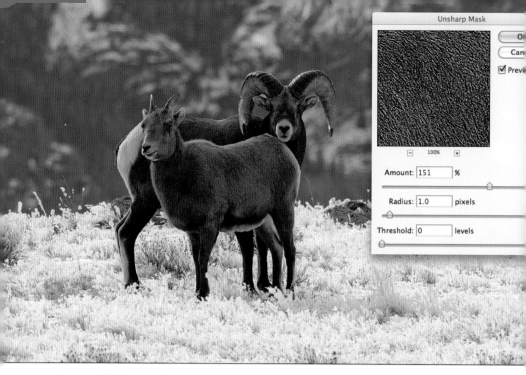

ABOVE: Unsharp mask is one of several ways to sharpen a digital image, and is probably the easiest to use. the Amount total in the percentage box can be set as high as you like, but the radius and threshold percentages must remain low for maximum sharpness.

Tip #8: Saving and Storing Your Images

Photographers have many different opinions on when, how, and where to save and store their digital images, but all agree that images should be saved at some point during the workflow sequence, and stored for future use.

As described earlier, the easiest thing for beginning photographers still learning Photoshop or one of the other post-processing programs to do is to make a duplicate copy of any image they intend to work on before they begin working on it. You can do this by opening the image, then clicking on Image > Duplicate. If you are shooting in the RAW format, keep the original in RAW and the duplicate in TIFF format. If you are shooting in JPEG, save both the original and the duplicate in TIFF format. In the RAW and TIFF formats, the image remains as it is when saved, but in JPEG, some pixel information is lost each time the file is re-opened.

Once you have completed your computer changes, save your re-worked image in TIFF format. If you intend to email the photo, create another duplicate, then resize the duplicate and save it as a JPEG, since it will be a smaller file that Internet servers can handle better.

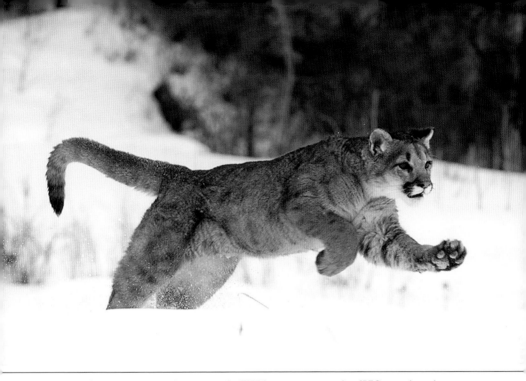

ABOVE: Save your processed images in the TIFF format, as opposed to JPEG, in order to keep from losing any additional information contained in the pixels. Storing files on the computer takes up valuable space, so use a small, portable external hard drive instead.

Final image storage is best done on an external hard drive that plugs into your computer. These are available at computer stores and in various capacity sizes. When plugged into your computer through a USB port, you can drag individual images into the hard drive, or create folders for easier location in the future. Professional photographers may accumulate a dozen or more external hard drives like this, and most take one on assignment for photo storage while shooting.

Using an external hard drive saves computer memory, and most of them today are small, rugged, and easily transportable. A large capacity hard drive of 500 GB or more, will store thousands of images, which is why it's important to organize your photos into folders you can find them quickly when you want them.

INDEX

4-16